Kasimir Malevich

Jeannot Simmen
Kolja Kohlhoff

Kasimir Malevich

Life and Work

KÖNEMANN

Malevich's Youth

Impressionism

1878
1918
1900
1922
1905
1925

Non-objective World

World System

Neo-primitivism
page 22

Victory Over the Sun
page 30

1910 1913 1915

1927 1930 1935

The Last Years
page 74

Malevich's Youth

1878–1903

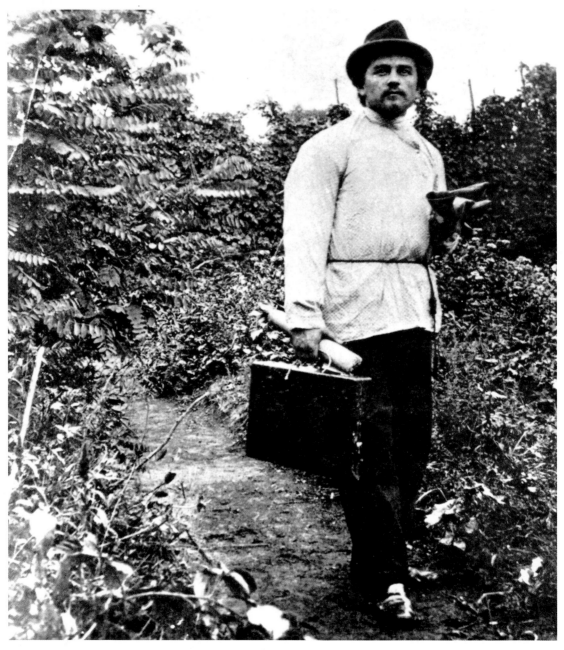

There is no indication, either in his childhood or his youth, of the later creative strength of Kasimir Malevich's pictures or the powerful effect of his artistic creed. The future leading avant-garde artist grew up in southern Ukraine far from any sizable city. Both parents were from Catholic Poland. His father worked in a sugar factory, on the twelve-hour night shift; he was later promoted from blue-collar to white-collar work. Their home was simple, without art books or works of art. As everywhere in Russia, there were icons on the wall, but they were of little importance. Both parents had parted company with the Church. Aged about fifteen, Malevich was given a paintbox. In Kiev, he and his mother entered a "shop with a lot of pictures in it, which made him excited," as he wrote in his autobiography in 1923. For the first time, he recognized painted realities. An idea dawned; at last he could use these paints to paint the impressions stored in his visual memory: "I shall never forget this great day."

Trans-Siberian Railway

Malevich ca. 1900

1878 Construction of Eiffel Tower starts in Paris.

1879 Birth of Stalin, Trotsky, and Einstein.

1881 Siemens builds first electric railway in Berlin.

1889 Lyubov Popova born.

1890 El Lissitzky born.

1891 Construction of the Trans-Siberian Railway (1891–1904)

1892 Collector Pavel Tretyakov bequeaths ca. 1,500 paintings to the city of Moscow.

1878 Kasimir Severinovich Malevich born on 11 (23)* February.

1896–1904 Malevich family moves to Kursk. Malevich works for the railway administration as a technical draftsman.

1901 Weds Kasimira Ivanovna Sgleits.

*Dates in brackets correspond to Gregorian calendar, which replaced the Julian calendar in Russia on February 14, 1918.

Opposite:
Malevich in Kursk, photo ca. 1900
On his way to study nature with his painting equipment

Right:
Moscow–Leningrad, detail
Map showing railway connections

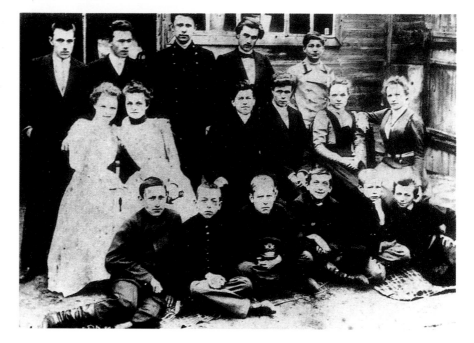

Malevich with friends of his youth, photo, November 1900, Kursk

Malevich (second right at back), and his future wife Kasimira Sgleits (center row, second from left)

Impressions of Nature and First Pictures

Kasimir Malevich was born in Kiev, Ukraine on February 11, 1878 (old, Julian calendar). He did not begin to paint until he was fifteen, as he explains in his autobiography (1923). Before that he was inspired by the continual changes of the natural world: "I remember well and will never forget that I was fascinated first and foremost by hues and colors, also storms, thunder, and lightning, and at the same time by the total calm after the thunderstorm," he writes. He was particularly excited by the alternation of day and night. The forty-five year old recalls his childhood: "How difficult it was to get me to bed, and tear me away from enthusiastically watching, from observing the shining stars in the raven-black sky."

In around 1896, he became interested in the works of the Russian school of Realism – pictures by Ivan Shishkin and Ilya Repin, who belonged to the Wanderer group of artists. When the Malevich family moved to Kursk in 1896, Malevich set up a joint studio with other painters and became acquainted with academically trained artists. The first pictures were completed, painted direct from nature. Dissatisfied with his efforts, Malevich sensed the necessity for academic training as an artist.

It was only then that Malevich discovered that there was a school in Moscow where painting was taught and where a picture gallery presented works of art. Even so, traveling to Moscow remained an unattainable objective, for which one would "need a magic steed."

To earn money for the journey, removal costs, and studies, he first had to become a clerk, and worked for several years as a technical draftsman in a railway office. During working hours, he often set up his easel and "painted the view from the window," which his superiors tolerated. By the age of twenty-six, he had enough money, in the fall of 1904 he traveled to Moscow, and from 1905 had painting lessons in the private workshop of art painter Fyodor Rerberg. The style of his early works remained within the formal canon of the period – they are traditional Symbolist or Neo-impressionist works. Unlike the Wanderer artists, his works are not indebted to any natural realism after 1850. In the first years of the 20th century, gazes were turning west. The first collections of French art were being established. Young artists were interested in the Impressionists, the modern art of the time.

Portrait of his mother, 1900
Oil on canvas
42 x 37 cm
St. Petersburg, State Russian Museum

The first known oil painting by Malevich is painted realistically, using natural colors. It highlights the intense gaze of his mother and the visual understanding of the world. Her gaze is more than just inquisitive; spellbinding would be a better term.

In Kiev in his youth, Malevich had seen a "picture" for the first time. This work showed "in the most tasteful manner possible, a girl sitting on a bench peeling potatoes. The potatoes and peel were strikingly genuine. It left such an indelible impression on me as if it came from nature itself. This was a portrayal of a human figure just as on the icons, but for a particular reason it attracted my utmost attention and stirred up an unusual excitement in me, such as was not the case with the icons."

Kasimir Malevich, 1923

"However small this giant may make himself, he always appears as almighty Zeus, before whom all Olympus trembles even at his frown," Ilya Repin wrote about the author of *War and Peace*. Repin was a close friend of Tolstoy and often visited him at his country house. Following a first study in 1891, Repin then embarked on Tolstoy's portrait, attempting to capture the message of Tolstoy's life in it. Tolstoy strove for simplicity, and himself performed physical, rustic tasks. Repin shows Tolstoy in his favorite maple wood. The poet can be seen in the throes of concentration and is completely sunk in thought. Barefoot, he is at one with nature while he prays. Repin took ten years over the portrait of his important friend.

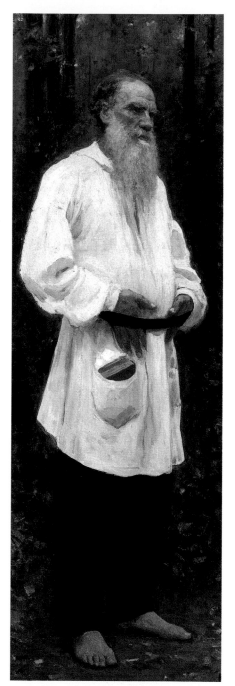

Russian Art Around the Year 1900

In 1861, fourteen graduates of the St. Petersburg Academy of Art applied for the Grande Medaille d'Or, a much coveted art prize. They asked their professors to be allowed a free choice of subject, as they refused to paint solely religious and mythological subjects. When their request was rejected, they left the academy. There was a disagreement, and Russian art took a new direction. According to the young artists, painting should tap into reality and depict real situations of life. People should be shown not as types but as individual characters. Attention should focus not so much on their external appearance, but their inner life should be brought out. This made a considerable contribution to the development of the psychological portrait. For the first time, the native landscape also became a topic for painting. That artists treated all social classes even-handedly was received particularly well by the bourgeoisie, although not with the Tsarist court or nobility.

Because the young painters were excluded from the exhibitions that were organized by the Academy, in 1870 they founded the "Traveling Exhibitions Cooperative," which earned them the nickname of peredvishniki or "Wanderers." Their first exhibition made a successful tour of forty-eight Russian towns. The association subsequently organized

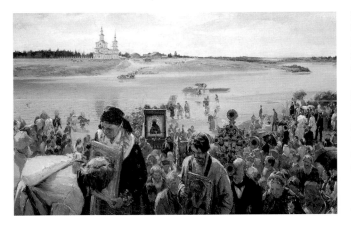

annual exhibitions for four decades before finally disbanding.

From the very beginning, the Realists were patronized by the Moscow merchant P. M. Tretyakov, who in 1892 donated his huge collection of Russian art to the city of Moscow. This became the first museum for Russian art, which still exists today as the State Tretyakov Gallery. By this time, Russian Realism had itself become the accepted academic style. Its most important representative, Ilya Repin (1844–1930), taught at the St. Petersburg Academy. Thus, as could hardly fail to happen, the next generation of painters rebelled in their turn against the one-time stirrers and shakers. They took their cue mainly from French painting, and in 1898 set up a new association called the World of Art, which was to become the forerunner of the Russian avant-garde movements of the 20th century.

Above:
Ivan Pryanishnikov,
Procession, 1893
Oil on canvas
101.5 x 165 cm
St. Petersburg, State
Russian Museum

The "Wanderer" Pryanishnikov was one of the most important genre painters of his time. His preferred subject matter was life among Russia's rural population. All of his pictures have a socio-critical aspect. The theme of the procession enabled him to depict members of all classes and various types of people together in a single picture. The onward flow of the river merges with the procession itself. The cold, silver-green color tones of the picture reflect the mood of northern nature.

Below:
Valentin Serov,
Portrait of Sophia Botkina, 1899
Oil on canvas
189 x 139.5 cm
St. Petersburg, State
Russian Museum

Serov belonged to the next generation of artists. His greatest successes came in 1900. As a pupil of Repin, he was initially a Realist, then threw in his lot with the Symbolists. He was a representative of the transition between history painting and modern art. He achieved great fame with his portraits. This portrait shows Sophia Botkina, the wife of Moscow merchant and collector Botkin. She sits alone on an overlarge sofa. She occupies only the right half of the picture, while the other half remains empty. Within the picture she looks lost, depressed, and melancholy. The bright yellow, pink, blue, and black of the palette create this mood. Although this is intended as a public portrait, Serov shows the woman in great solitude. The picture expresses the mood of the *fin-de-siècle*.

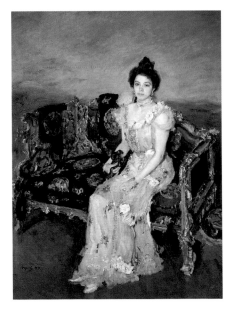

Impressionism

1904–1907

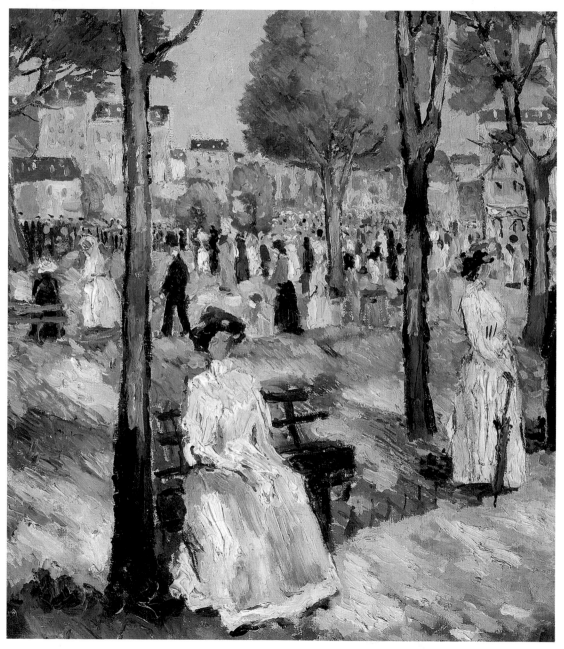

Even before Malevich could set out on the long-awaited journey to Moscow, he was aware of the latest fashions in art from periodicals. When he arrived in Moscow in 1904, he already had Impressionist paintings of his own in his luggage. He was excited by the Impressionists' depiction of nature and especially their handling of color. His own experience of nature in childhood and youth influenced his pictures, which are very expressive of mood. In Moscow he had an opportunity to see French originals in private collections. He was profoundly impressed by Monet and Cézanne in particular. An effervescent Moscow provided him with much artistic and intellectual stimulation. He quickly established contact with the younger artists in the city and was to exhibit jointly with them. Late Impressionism and Symbolism remained the styles on which he modeled himself.

First Russian Revolution, 1905

Malevich in 1905

1904 Russo-Japanese War. World association supports women's suffrage.

1905 Revolution in Russia, resulting in deaths in front of the Winter Palace in St. Petersburg.

1906 First Russian *Duma* (parliament) assembles and is dissolved because of its radical demands.

1907 Lenin flees abroad. Universal suffrage in Austria.

1904 Malevich travels to Moscow and visits the studio of Fyodor Rerberg in Moscow.

1905 He fights on the barricades during the uprising in Moscow.

1907 Malevich exhibits his works for the first time at the Fourteenth Exhibition of the Cooperative of Moscow Artists. Other exhibitors include Kandinsky and Goncharova.

Opposite:
On the boulevard, detail, 1903
Oil on canvas
55 x 66 cm
St. Petersburg, State Russian Museum

Right:
Sketch for a portrait of Roslaviv, 1907–1908
Drawing
11 x 12.3 cm
Amsterdam, Stedelijk Museum

Impressionism as a Starting Point

Boulevard, 1903
Oil on canvas
56 x 66 cm
St. Petersburg, State
Russian Museum

In front of a backdrop of houses and a crowd of people, a young woman takes a baby out in a pram, pushing the pram parallel to the frame along a path in the park. The white mob cap and pinafore that she wears mark her as a nanny. Malevich uses the primary colors of red, yellow, and blue for the pram and woman. The pram gleams yellow, the cover blue and red, like the servant's clothing. They stand out starkly from the green of the park. The red/blue of both cover and clothing also show that the pram and woman belong together. Her facelessness and the color identity with the cover, define her solely by her activity. She is represented not as an individual but through her job as a servant.

In the same way as the Russian Wanderers, the French Impressionists also found their subject matter in their surroundings. Along with landscape painting, they concentrated on painting modern life in the streets, parks, and cafés of Paris. In contrast to the realism depicted by the Wanderers, their aim was the recording of a direct impression. A sense of atmosphere had to be brought out. There was no attempt at conveying either heroic or moral aspects in paint. Favorite subjects of theirs were everyday life and light.

With glowing colors and rapid brushstrokes, the painters endeavored to capture changes of the moment. Visible brushstrokes demonstrated that their pictures are just paintings. This gives them a somewhat sketchy almost blurred character. For their predecessors, such work would have been considered unfinished. In order to show nature in its constant variation, the Impressionists set up their easels directly in front of the subject matter, thereby founding the open-air school of painting.

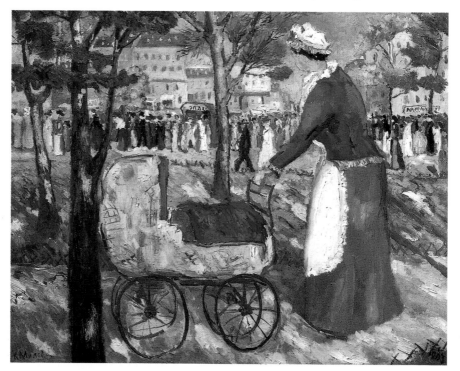

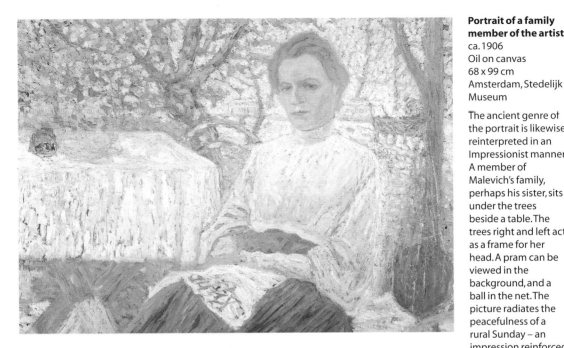

Portrait of a family member of the artist, ca. 1906
Oil on canvas
68 x 99 cm
Amsterdam, Stedelijk Museum

The ancient genre of the portrait is likewise reinterpreted in an Impressionist manner. A member of Malevich's family, perhaps his sister, sits under the trees beside a table. The trees right and left act as a frame for her head. A pram can be viewed in the background, and a ball in the net. The picture radiates the peacefulness of a rural Sunday – an impression reinforced by the light color tones and the lack of strong contrasts. With her hands in her lap, the woman looks restful. She appears to survey the viewer with a calm, almost expectant gaze. In this picture, Malevich was experimenting with various painting techniques: nature is painted with spots, while the table cloth and clothes are applied with thick streaks of paint. However, the face of the woman is painted with traditional naturalism.

Malevich knew the work of the French Impressionists from seeing reproductions in periodicals. Here he discovered how to express his love of nature in art. A year before he had even left for Moscow, he was painting in an Impressionist style, thereby already utilizing the mainstream style of his day. It was, however, not the scenes of city life that interested him. His pictorial subjects were gardens and parks, as well as the people that chanced to be in them. The pictures of people remain anonymous and distanced, in a way like snapshots. Unlike the French Impressionists, however, Malevich entertained no ambitions to capture the effects of light in his pictures. He relied solely on the effects of color. Colors themselves become sources of light in his work, which he boldly juxtaposes in their vividness. Connected colored surfaces replace the minutely dissected shimmer of Impressionist pictures. He also stuck more closely to a compositional frame, for which trees were often used to provide a horizontal and vertical axis. That he managed to raise himself from the provincial to the top rank of young Moscow artists, bears witness to his fierce determination to seek new fields.

The Experience of Nature and Landscape Painting

This painting is captivating in its calm and tranquillity. The viewer is looking into an orchard in front of a farmhouse. The orchard is enclosed by fences. Nothing disturbs the peace of the place, and neither people nor animals are visible. The green and light pink of the apple trees and blossom characterize the whole picture. The colors recur in various places, for example, in the green roof and pink path. Contrasting with these is the bluish purple that characterizes the sky, the fences, the trees, and their shadows. The repetition of colors provides Malevich with a unified effect and homogeneous atmosphere, so that the whole picture seems to blossom.

Landscapes as subject matter tend to be peaceful. It has always been less a matter of what is painted, rather than how it appears in the picture. This was precisely why landscape painting experienced such a major upturn in the late 19th century. In Malevich's case, an artistic quest for new kinds of representation can be detected in his landscape pictures. He chooses specific pictorial sections that are like views through windows. There are always houses visible behind trees. It is thus nature as cultivated by man. In this, the rustic environment of his homeland determined the subject matter. He paints objects in a soft afternoon light using pastel colors, with the trees casting long shadows. An encounter with Monet's pictures in Shchukin's collection provided a new impetus to his development. Kandinsky is reported to have exclaimed, both horrified and enthusiastic, on seeing Monet's paintings: "That's just color." Malevich must have fared similarly. The absence of spatial depth and the quasi-relief structure of color must have fascinated him

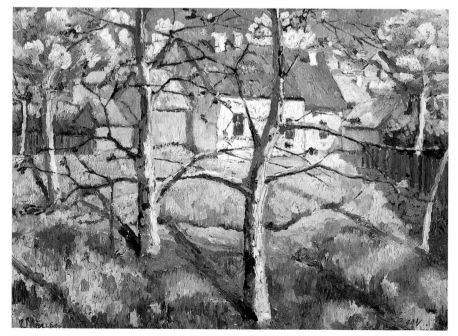

strongly. That a picture could consist only of spots of color left a lasting impression on him, and he comments in his essay *The new systems in art* (1919): "Monet focuses entirely on exploring the art that grows on the walls of a cathedral." Malevich was less interested in the reproduction of light achieved by Monet's "cultivated" color spots, than in the use of color. For him, the main concern was the material quality of the picture shown in its quasi-relief structure. In 1906/07 he experimented with this style of painting before moving, briefly, to painting in a Symbolist style.

In front of me, between the trees, stood a freshly whitewashed house. It was a sunny day. The sky was cobalt blue. One side of the house was in shadow, the other was in the sunlight. I was aware for the first time of the bright reflection of the blue sky, the pure, transparent tones. From this moment on, I began to paint in bright, sunny colors.
From this moment on I became an Impressionist.

Kasimir Malevich, 1930

Landscape with yellow house,
1906–1907
Oil on card
19.2 x 29.5 cm
St. Petersburg, State Russian Museum

The outline of a house appears, as if on a pulsating surface, between pale violet, vertical streaks that represent trees. Due to the primary colors that are used, it gleams powerfully. The picture breathes through the splashes of color.

Relaxation. Company with Top Hats

Company with top hats,
1907
Water color, ink, and pencil
on paper
16.5 x 15.6 cm
Cologne, Museum Ludwig

Company with top hats

This unfinished gouache shows a group of elegantly dressed people gathering, meeting, and shaking hands. The title itself indicates that they originate from the bourgeoisie. The figures circle around the center of the picture as if dancing a roundelay. A stylized park with three trees forms the center of the design. Around it, like a moat, is a lake, on which boats sail. Trumpet-blowing creatures reminiscent of angels seem to protect the park. The only part finished in color is in the top left of the picture. The rest is formed of pencil outlines which are partly painted over in ink and thereby highlighted. The central tree and angelic figures are motifs derived from Judaeo-Christian paradise imagery. The figures circle around the closed-off island but never actually reach it. Nonetheless, they seem quite content with their surroundings.

Thus, the happy strolling of the bourgeoisie is depicted as a small Sunday paradise that is, nevertheless, always separated from the real paradise.

A Sunday picture

The theme of Sunday idleness was very popular in 19th-century French painting. Pictures show the bourgeoisie spending their day off in the open air. In contrast to the aristocracy, who did not work, this was the day allocated to citizens for relaxation and showing off. People dressed up in their Sunday best to parade in the parks or went to the country to escape growing urbanization for a while. The larger and louder the towns became, the more people longed for the peace of nature. For the Impressionists, who themselves came from the bourgeoisie, the subject matter was a welcome excuse to go out into natural surroundings and paint in the open air. Malevich took up the theme, but painted it in a new way. He was less interested in reflecting the light effects of nature in his pictures. It was also not his principle purpose to paint the bourgeoisie, whose status in Tsarist Russia was quite different from France. Malevich's pictures tended, in fact, to adopt Impressionist subject matter but execute it in the style of the Symbolists.

Ornamentation in place of impression

In his picture *Relaxation*, Malevich shows thirty people in a meadow. They are distributed over the entire pictorial surface, with each figure in a different attitude. Their almost exclusively white clothing contrasts strongly with the green background. Color accents between orange and purple are dotted in between as hats, hair, shoes, flowers, and parasols. They look like points of light in the picture. Two men dressed in black also stand out. These people have no relationship with one another, neither speaking nor playing or even eating together. Only the white of their clothing appears to unite them into a single group. The people formed by the outlines are reminiscent of cardboard figures; their incorporeal flatness is additionally emphasized by the lack of any shading or spatial depth. Malevich shows us neither nature nor the atmosphere surrounding the people. The picture is

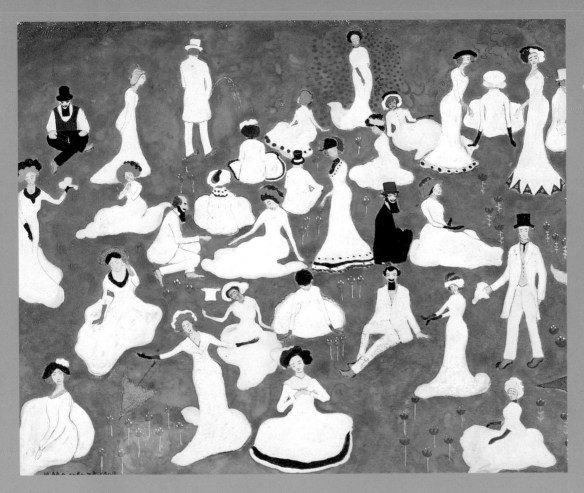

like a carpet with an irregular pattern, and thereby appears both ornamental and decorative. In this respect, the picture follows the tradition of Symbolism – a style that replaced Impressionism. However, Malevich adopted only its innovations of form, not the often mystic, heavy subject matter. In this way, he creates a strictly constructed picture that is nonetheless light and cheerful. Indeed, thanks to the male figure at the top brazenly urinating on the grass, this attains a note that is at once witty and critical. Malevich is here making fun of the apparent prosperity of the bourgeoisie.

Relaxation. Company with top hats, 1908
Mixed technique on card
23.8 x 30.2 cm
St. Petersburg, State Russian Museum

Important Collectors in Moscow

The Music Room in Sergei Shchukin's house, with paintings by Monet and other Impressionists, photo ca. 1913

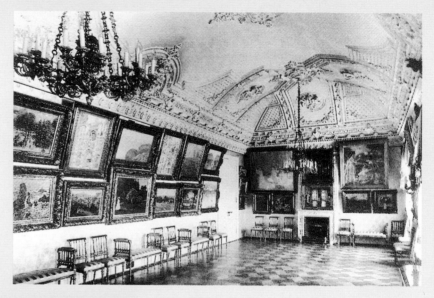

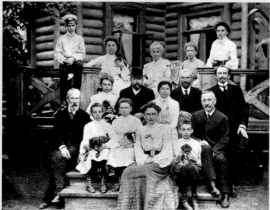

The Shchukin family at their dacha, photo ca. 1900

Important collectors in Moscow

Two Russian collectors stood out at the beginning of this century: the cloth merchant Sergei Shchukin (1854–1936) and the textile manufacturer Ivan Morosov (1871–1921). Both acquired modern French art and publicized it in Russia. After initially buying the now long forgotten academic painters of the Salon in Paris, they developed a fine feeling for new trends.

Shchukin was especially keen on the paintings of Claude Monet, and in the following years was to concentrate his attention on Impressionists. Their works adorned the music room or "White Drawing Room" of his villa in Moscow. By 1904, he owned fourteen Monets. When he felt that Monet could not possibly improve any further, he turned his attention to the artists of the next generation. He developed an ambition to introduce the latest art developments to Moscow, and thus, in the following years, pictures by Cézanne, van Gogh, and Gauguin were added. Gauguin's South Sea pictures hung frame to frame in the dining room. In their tendency towards primitivism, Shchukin perceived an affinity with Russian art. Artists were welcome guests in his house, and were there offered the opportunity to become acquainted with French art at first hand.

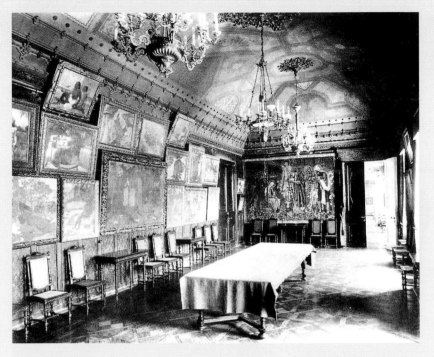

Grand dining-room of Sergei Shchukin's house, with pictures by Gauguin and a tapestry by Edward Burne Jones, photo ca. 1913

From 1910 onwards, Shchukin took up the young artist Henri Matisse, and commissioned several large-scale pictures from him. Due to his patronage, the pictures *Music* and *Dance* (1910), later to acquire worldwide fame, were painted for his stairwell. Many of his visitors reacted with bafflement to these latest developments, so that Shchukin jokingly remarked to the Russian writer Pasternak; "A madman painted it and a madman bought it." Through Matisse, Shchukin got to know Pablo Picasso, who became the final master in his collection. At the outbreak of the First World War, Shchukin owned the largest collection of Picassos in the world. Fifty-one pictures in two or three rows covered the whole room, in the same way as a tapestry, right up to the ceiling.

Ivan Morosov's passion for art began at the same time as Shchukin's. Initially he collected the works of the young Russian Symbolists, but after his villa was rebuilt in 1907, he too preferred French art.

Morosov entered into fruitful competition with Shchukin. Whereas Shchukin was somewhat more adventurous, Morosov collected more prudently. He focused on fewer, more select works of the highest quality. In addition to the pictures of the famous artists that Shchukin also owned, he concentrated principally on the Nabis who were a group of artists, a short-lived movement in French painting characterized by a vivid, decorative painting of surfaces. Morosov had a whole room adorned with large-scale pictures by their main representative Maurice Denis. It was he who commissioned the sculptor Aristide Maillol to make several bronze figures for this room.

From 1910, both collectors opened their houses to the public on Sundays. They personally conducted curious visitors around their collected treasures.

After the October Revolution of 1917, both collections were confiscated by the state and turned into museums. Their owners fled abroad with their families. In the 1930s, the pictures were shared out between the Pushkin Museum in Moscow and the Hermitage in Leningrad. However, they soon vanished into storage. Stalin's cultural policy did not approve of them. Not until the 1960s did they gradually reappear. Thus, thanks to the courage of the private collectors, both museums now sparkle with the best works of the French transition into modern art.

Neo-primitivism

At this time, St. Petersburg and Moscow were the great political and economic centers and the cultural metropolises of Russia. In 1907 Kasimir Malevich moved permanently to Moscow with his mother, wife, and daughter. In the spring, he showed twelve pictures for the first time, at the fourteenth Exhibition of the Moscow Artists' Union. In the joint exhibition works by fellow artists were presented, who later featured as forerunners of modern art, for example Vladimir Bourlyuk, Natalia Goncharova, Vassily Kandinksy, and Mikhail Larionov. In spring 1908, the Golden Fleece exhibition opened in Moscow, showing Post-Impressionist works, including Nabis and the Fauvists, works by Pierre Bonnard, Maurice Denis, Henri Matisse, Vincent van Gogh, Paul Gauguin, and Georges Braque. Malevich was impressed by the exhibition, and traces of his critical interest in the work of the leading artists of western Europe can be seen.

Coco Chanel becomes a milliner in Paris in 1909

Malevich ca. 1912

1908 Cubism is born.

1909 Shchukin commissions *Dance* and *Music* from Matisse.

1910 Leo Tolstoy dies aged 82.

1911 First Moscow *salon* for modern painting. First Blauer Reiter exhibition opened at the Tannhauser gallery in Munich.

1912–1913 Balkan wars, weakening the political leadership of Russia.

1908 Malevich sees works by the French Nabis and Fauves movements (Bonnard, Matisse, Derain etc.) in Moscow.

1909 Malevich separates from his first wife and marries Sophia Mikhailovna Rafalovich.

1910 First exhibition of the Karo-Bube group of artists in Moscow, with works by Goncharova, Kandinsky, and Malevich.

1912 Matyushin and Malevich become acquainted.

Opposite:
Self portrait, detail, 1908 or 1910–1911
Mixed technique on paper
46.2 x 41.3 cm
St. Petersburg, State Russian Museum

Right:
Sower, ca. 1911/12
Pencil on paper
12.3 x 12 cm
Cologne, Museum Ludwig

The Search for Self – the Self-portraits

Malevich was about thirty years old and no longer a young artist. Dissatisfied with himself and his work, he looked for new forms of expression. This search for the self was manifested in painting by the self-portraits of 1907–1909. At the same time, he had a close look at the ubiquitous tradition of icons in the Russian pictorial world, the sacred images of the Orthodox Church. These religious pictures demonstrate to the faithful the life of the saints. Malevich discovered in icons painted in primary colors a "theology in colors" beyond the realistic representation of nature.

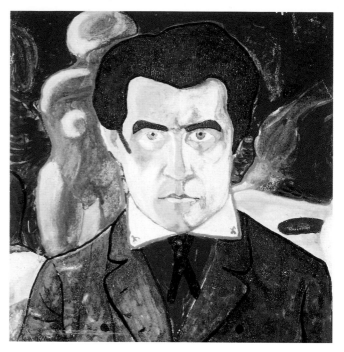

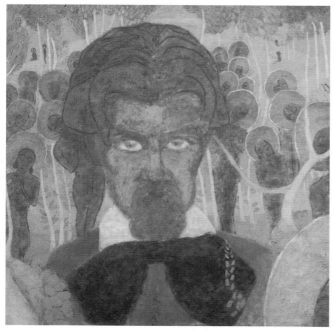

Sketch for fresco painting, 1907
Tempera on card
69.3 x 70 cm
St. Petersburg, State Russian Museum

The artist looms large in the foreground, like a religious redeemer of the lamenting background figures. Both the portrait and background are painted in a single color tone. Subject matter, color, and composition are all Symbolistically charged. The colors are used to portray sensuousness and melancholy feelings.

Self portrait,
ca. 1908–1909
Mixed technique on paper
27 x 26.8 cm
Moscow, State Tretyakov Gallery

The light facial form, with the black hairline above and two shirt points below, form a bright surface in the layout. This can be seen as an early presentiment of quadrilateral forms. The head appears to be detached from the body, and its strictly parallel positioning in the frame is reminiscent of an Abgar icon.

Through the Blue Rose exhibition in 1907, Malevich became acquainted with the works of the Moscow Symbolists. These works caught his interest, and a year later he exhibited the Symbolist *Studies for Fresco Painting* (opposite). The self-portrait shows the artist sporting a beard and center parting in front of a background of naked saints' figures in a wood.

Barely a year later, 1908–1909, a great change became evident. The *Self Portrait* gouache shows the artist standing out clearly from the background. The figures in the background are female nudes, which are not religious but characterized by their red color. The self-portrait of the artist is bordered with black contour lines and thus separated from the background. The red leaps optically forward, while the dark color surfaces lead backwards. The contrast shows the conflict between the artist and his physical desire. The insistent eroticism has, however, been banished into the background.

Both of these shoulder-length portraits are full frontal, the eyes staring, everything composed on a central axis, like the Abgar mandylion of the Eastern Church. Legend tells the story of a painter who was so fascinated by the radiant countenance of the Redeemer that he could not paint Him. When Jesus noticed this, he took the "painter's linen robe, put it over His face and pressed His picture on it." The result was the mandylion, an authentic and direct print of Jesus' face.

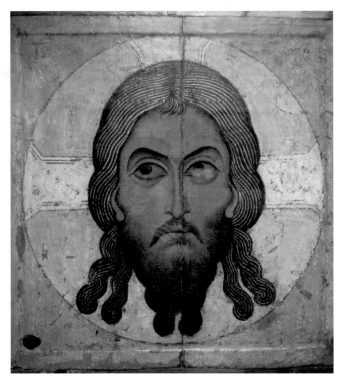

Acheiropoietos [Gk. "not made by hand"], 12th century Tempera on wood, ca. 77 x 71 cm Moscow, State Tretyakov Gallery

An Early Christian source (cited in the medieval Golden Legend) tells the story of the black King Abgar of Edessa, who heard of Jesus the miracle healer. As he himself could not go to see him, he sent a painter instead. The painter was blinded so much by the radiant face of Christ that he could not paint it. Jesus noticed this, took the artist's robe, pressed His face on it, and sent it to King Abgar. Captured forever were the fine eyes and eyebrows, the face that was "narrow and gently inclined, which is a sign of maturity," in the words of the *Golden Legend*.

Mandylion icons follow a strictly frontal representation. The schematic portrait could not be changed or individualized by the monks who copied it. It could not be a shoulder-length reproduction, but only a head which appeared to be floating and detached.

A noticeable feature here is the sideways gaze, which lends the image an individual character. It is only this apparently trivial feature that makes the portrait living and human.

Neo-primitivism

Bather, 1911
Mixed technique on
paper, mounted on
paper
105 x 69 cm
Amsterdam, Stedelijk
Museum

There is none of the
elegance and
stylishness that is
demonstrated by
Matisse to be seen in
Malevich's work. He
tends more towards

coarse figures whose
movements appear
clumsy. The figure is
outlined in black, the
volumes are modeled
in red, illustrating
physical weight.

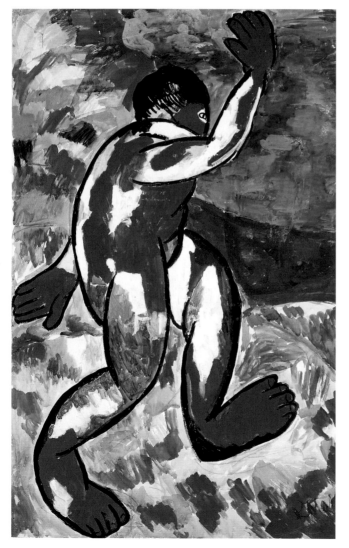

In 1910, still continuing his search for new forms of expression, Malevich turned to "primitive" art. As well as with Russian folk art, which strongly influenced him, he was now fascinated by the artists of the Neo-primitive avant-garde of Western Europe, the Fauvists (Fr. *fauve*: "wild beast"), who were breaking down ossified academic art by means of direct artistic action. Malevich developed a contoured painterly representation. Pictorial figures were flattened out and the pictorial background only suggested. Naturalistic representation was completely abandoned, depth perspective dissolved.

In December 1910, the Moscow collector Sergei Shchukin acquired two large-scale works for his upper-class villa, namely *Dance* (La Danse) and *Music* (La Musique), both by Henri Matisse. In these pictures, the pictorial space is suggested decoratively; the figures appear as if silhouettes in front of it.

Malevich, himself, broke away from realistic and naturalistic representation. He also abandoned static representation. Everything was invested with motion. The picture became a single frame in a sequence of change. The use of black outlines emphasizes the figures, but at the same time they become more strongly detached from their surrounding space. Patches of color indicate corporeality and depth of space. They are not, of course, applied realistically but instead are placed

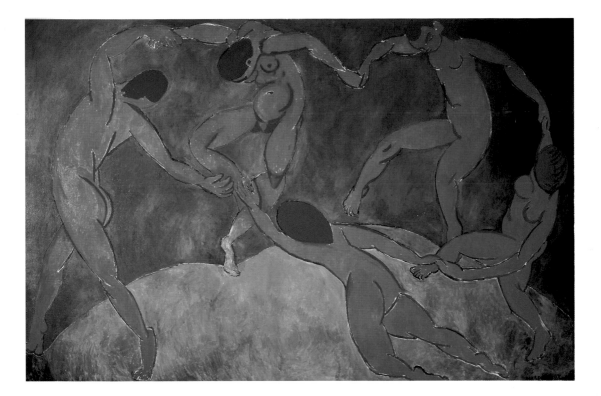

decoratively, in other words positioned principally in accordance with aesthetic considerations.

Unlike the primitive works of folk art, Malevich drew upon modern French painting for his sources. Matisse may have been the prime inspiration, but Malevich did not copy his work: it was his own vision alone that he painted.

The work of a realistic artist reproduces nature as such and represents it as a harmonious, organic "whole." In such a reproduction of nature no creative element can be recognized, because the creative element is not the unalterable synthesis of the artist's conception. An artist who does not imitate, but creates, gives expression to himself; his works are not mirrors of nature but new actualities that are no less important than the actualities of nature itself.

Kasimir Malevich, 1927

Henri Matisse, **Dance**, ca. 1910
Oil on canvas
260 x 391 cm
St. Petersburg, State Hermitage

This work, in large format, was commissioned for the stairwell in the Villa Shchukin. The radical simplicity, decorative movement, and weightless elegance of the figures are reinforced by the color contrast.

Right:
Lumberjack,
1912–1913,
oil on canvas,
94 x 71.5 cm
Amsterdam, Stedelijk
Museum

Figure and ground, in other words the lumberjack and the pieces of timber, are treated alike by the painter. Foreground and background are no longer separated formally and in coloring, but are unified. Representation of perspective is abandoned. Malevich is not interested in reproducing objects but in a new approach to the representation of the entire pictorial space. Time is still bound to space. The lumberjack looks suspended as if in a frozen pose.

Pablo Picasso, **"Jolie Eva" violin**,
1912
Oil on canvas
60 x 81 cm
Staatsgalerie,
Stuttgart

Cubism breaks the subject matter into its details, in this case a violin and a female body which are visible from all sides at the same time.

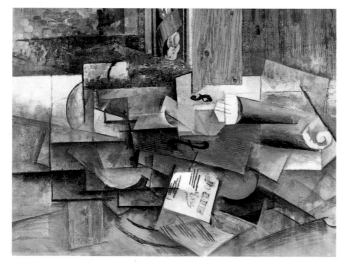

Dissecting Space and Time

In 1912, the pace of change in Malevich's development increased as he reached a turning point, and developed a new, independent style. Naturalistic forms of representation became abstract, space and time were taken apart in the picture. Henceforth, Malevich threw himself into the creative appropriation of Cubism. This, the most up-to-date style that was to emerge from the Paris studios of the time, broke down pictorial objects into geometric elements, that is into cubic shapes, presenting them from a variety of different angles. Meanwhile Futurism, a style developed in Italy, was attempting to reproduce modern life and technology as visual motion, that is to say dynamically. Time was painted as time passing. Malevich experimented with both styles and discovered the first radical changes in his depictions of space and time.

However, in Malevich's work – in contrast to the Cubists – space is not just broken up and segmented but also flattened out. The background is optically tipped forwards and the spatial depth made more vertical. The figures are flattened and thus they lose plasticity. They consist only of simple forms, and look like voluminously curved circles, cylinders, or trapezoids. At the same time, Malevich tried to redefine the segmented surfaces. The surfaces are endowed with a metallic quality and

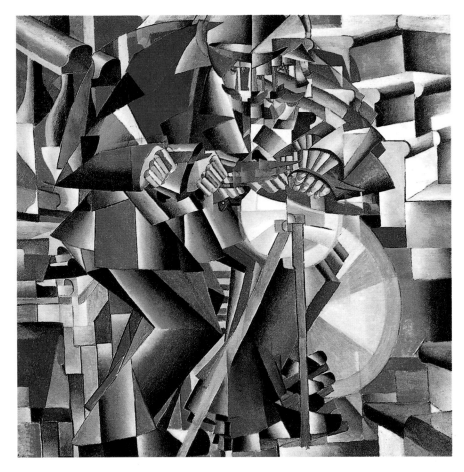

**Knife-grinder.
Principle of
flickering**, 1913
Oil on canvas
79.5 x 79.5 cm
New Haven, Yale
University Art Gallery

This picture shows not a moment in time, but the constant rotation of wheel and the movements of the operator. The background is likewise set in motion, so that the whole picture does not have a single static anchor point. By abandoning the pictorial ground as a point of rest, Malevich set himself apart from Futurism, which still retained it and showed (for example) a moving vehicle in front of a static background. The title itself, *Principle of flickering*, refers to Malevich's abandonment of the physical object. The representation of the operator and his work is shown dynamically, like a jerky film being projected. About this time the physical theory of waves was developed, which no longer interpreted the world as static.

have a technoid appearance. Time in the pictorial space is symbolized by depictions of work. The pictures show an action: the lumberjack chopping, the grinder at his rotating wheel. Change of motion, in other words acceleration, is represented pictorially. Time, made dynamic, dissolves the traditional frontiers of space. Around 1913, Malevich's output was concerned with changing time. Writing in retrospect in 1927, Malevich summed up this indepen-dent innovation as an additional element to the new painting. He describes his invention as a logical continuation of Cubism and Futurism. His contribution was the domina-tion of time over space, the aban-donment of space as a principle of ordering. Avant-garde artists in Paris, Rome, and Milan did not dare go so far. The technique of collage brought back abandoned space into painting – artistically a step back-wards in form.

Victory Over the Sun 1913–1914

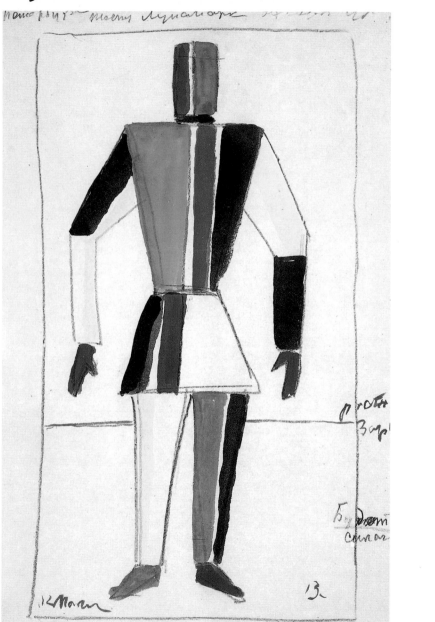

During a summer holiday in Finland in 1913, the writer Kruchonykh, the painter and composer Matyushin, and Malevich himself called together the First All-Russian Futurist Congress. They issued a manifesto that announced a performance of the opera *Victory over the Sun*, which was to break with all conventions. The public was divided, both euphoric jubilation and total rejection accompanying the two performances of the opera at the end of the year in St. Petersburg. Its two acts set forth how the sun is captured and the empire of strong men begins. "Sun, you have sired passions, / And you have burnt with kindled beam. We will cover you with a film of dust, / We will lock you in a house of concrete," sings the Strong Man. Victory over nature leads into the "futurist" realm. Malevich designed the geometrically devised costumes and stage sets. For him, the opera became a springboard for a new artistic, painterly language.

Model T Ford, Detroit, 1913

Malevich, 1913

1912 Universal suffrage in Italy

1913 Prompted by Lenin, Stalin writes *Marxism and the National Question* while he is in Vienna, demanding national self-determination. Proust begins his novel *À la recherche du temps perdu* (1913–1927).

1912 Exhibition of present-day art. Malevich exhibits *Woman with bucket* (1912) and *Child and harvesting woman* (1912).

1913 Malevich turns towards the Cubo-Futurists. 18–19 July *First All-Russian Futurist Congress* in Matyushin's summer house in Uusikirkko (Finland). Work begins on *Victory over the Sun* and a manifesto is drawn up.

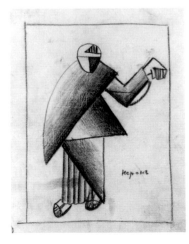

Opposite:
Strong man, detail, 1913
Water color, graphite pencil on paper
53.3 x 36.1 cm
St. Petersburg, State Russian Museum

Right:
Nero, 1913
Black chalk
27 x 21.5
St. Petersburg, State Museum of Music and Theater

The Costumes for the Opera

The Futurist opera *Victory over the Sun* was to be a slap in the face for public taste. It celebrated technology overcoming nature. After the women in this play have been locked up, the final struggle against the life-giving sun takes place and the empire of strong men is established. The "supersensory work" is directed against "worn-out common sense." It propounds a new form of reason that is devoid of all logic. The illogical language of Kruchonykh is combined with the music of Matyushin, which consists of noises and cries.

The stage sets and costumes were designed by Malevich. Years later, the poet Lifschitz recalled that they had been the "shining focal point" of the opera. The costumes were reminiscent of the Cubo-Futurist pictures executed by Malevich. Masks were often used in conjunction with them, so that the human body totally disappeared. All the actors' parts in the piece are rendered anonymous by titles such as the "Athlete," the "New Man," a "Malevolent One," or "the Many and One." The costumes were made out of card and wire. The rigidity of material used did not permit normal ease of movement, so that the cast moved stiffly and woodenly in them. Nonetheless, they did not seem like robots because there was nothing of the machine about them. Due to the fact that individual features of their

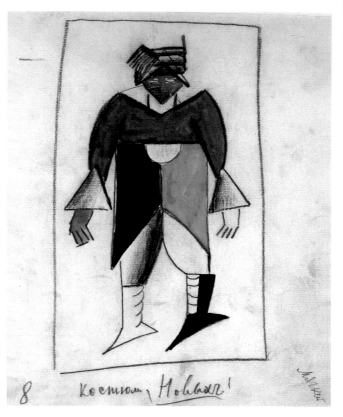

The New Man, 1913
Black chalk, water color, and Chinese ink
26 x 21 cm
St. Petersburg, State Museum of Music and Theater

"The New Man" is a figure from the realm of the Strong Man. He does not belong among the multitude, who "from improbable ease" do not know "what they should do with themselves." His face is a green lozenge, in which the eyes constitute only narrow slits. On top of his head, he wears a hat. A violet upper garment, cut off at the navel, and a V-shaped neckline pick up the triangular shape of the lower face. The upper garment is completed by a skirt, divided vertically into a black and a yellow surface. It is reminiscent of a pennant or coat of arms. The upward pointing triangular forms of the shoes and cuffs form a counter-movement to the downturned triangles of face and sweater. Cuffs, shoes, and pennant-skirt give the New Man the appearance of a stylized knight. Although he is a figure of the future, he appears as a being from the Middle Ages.

Many and One, 1913
Black chalk, water color, and Chinese ink
27.1 x 21 cm
St. Petersburg, State Museum of Music and Theater

"Many and One" embodies the masses and the individual at the same time. He wears a shining red costume. Black, fin-shaped points

emerge from the mask, back, and legs. As with the Futurists, these illustrate the energetic motor dynamism of the figure.

Before the performance of _Victory over the Sun_, photo, December 1913

The three authors, with Malevich on the right, pose before a painted bourgeois drawing-room background with a piano, which they have hung up upside down, symbolizing the upside down nature of the whole world.

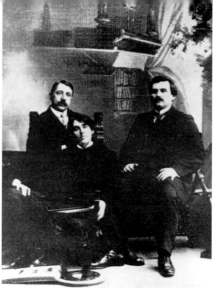

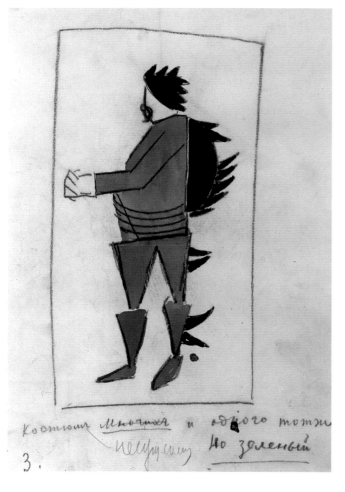

Костюм Многих и одного тоти
нецтуешин но зеленый

3.

costumes were highlighted in color, they appeared to be more like carnival figures or armed knights. Malevich used gleaming color tones and, for preference, used primary colors and black and white. The marking on the individual color surfaces is not arranged according to the organic connections with human anatomy. For example, part of an arm was highlighted or a leg, or paunch and mask become a single part of the body through sharing a color. The wooden mobility and accenting of color lent dynamism to the figures, which was independent of their physique. Their entry on-stage was to be regarded as a ballet of radiant color surfaces. This was a step towards an abstract pictorial logic.

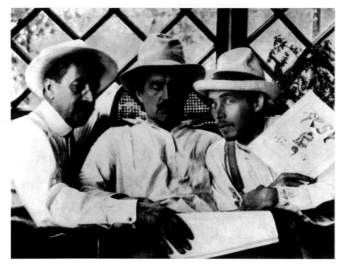

The fight with the sun ends in the third scene of Act 1. For this scene, Malevich painted a design in which spatial perspective becomes wholly unclear. The drawing is dominated by black surfaces. Except for three triangles and a circle, we find no purely geometrical forms in the picture. Gravity is dissolved optically. Top and bottom, left and right can be swapped around. On the edge of the stage, the number thirteen appears, the meaning of which is not evident.

The Stage Sets for the Opera

Having already reduced the figures in the opera to sundry expanses of color, Malevich continued the same process in the stage sets and curtain. The curtain was not raised but torn in half. The stage was bathed in a harsh, flashing light, which likewise fragmented the figures. They "lost hands, legs or heads alternately," Lifschitz wrote about the lighting production. In terms of color, the stage was in overall black, white, or green in the various acts. A green floor would also have green walls, while a black floor would have black or white walls. The stage backdrops of the individual scenes in the two acts deny any illusion of space: they represent characteristically segmented Cubist spaces. In the fifth scene, Malevich reduced the stage area

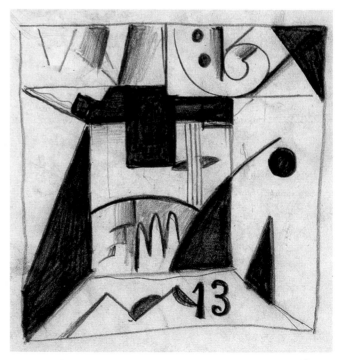

completely to leave the background only as a diagonally divided rectangle. This anticipated his pioneering innovation in art, although at this stage it was not formulated. A year later he wrote to Matyushin, who was preparing the designs for publication: "There's a curtain there, the black square, that I over-used, because it offers a whole range of material." In another letter, he wrote: "The curtain represents a black square, the core of all possibilities, that as it develops takes on a fearful power." The letter breaks off with the sentence: "It marks the beginning of victory."

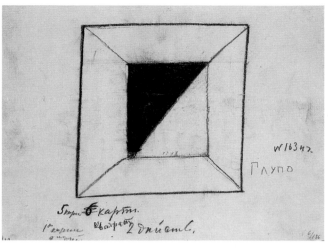

Scenery sketch, Act 2, Scene 5, 1913
Charcoal pencil on paper, 21 x 27 cm
St. Petersburg, State Museum of Music and Theater

Here, the design is confined to a diagonally divided rectangle at the back of the stage, creating a black and a white triangle. The white stands for the sun, the black for the darkness of the future.

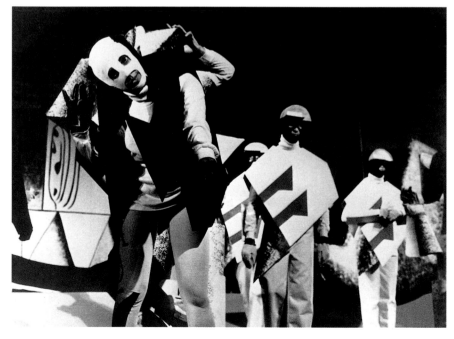

Performance of *Victory over the Sun*, California Institute of the Arts, photo Berlin 1983

The opera *Victory over the Sun* was reconstructed by the Berlin Festival and California Institute of the Arts, Los Angeles. The director of this production was Robert Benedetti and the producer was Alma Law. The first performance in English took place in Los Angeles County Museum of Art in 1980.

Illogical Painting

Russia, a giant country occupied by a nation of peasants subjected to the medieval rule of a Tsar, was in turmoil. World War I and the Balkans crisis hastened the process of disintegration. After a heavy Tsarist defeat, the semi-divine rule of the Romanovs went into decline. The bourgeois democratic February Revolution, which was followed by the Bolshevist October Revolution under the aegis of Trotsky, Lenin, and Tukhachevsky finally smashed the Tsarist regime in 1917. Radical social experiments forcefully catapulted a medieval society into the modern era.

The fine arts acted as both harbinger and commentator of these events. In Munich, Kandinksy developed a novel formal canon that would lead to abstract patterns and poetically laden colors. In 1911, he publicized his book *On the Spiritual in Art*, which had previously circulated in Russia in manuscript form.

For Malevich, the year 1913 was the turning point. Within a short space of time he developed the *Black*

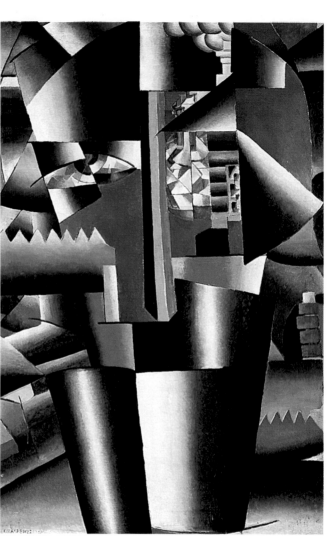

Ivan Klyun, photo, 1910

Malevich and Klyun developed a Cubo-Futurist style via Symbolism. In 1915, Klyun co-authored the manifesto *Exhibition 0.10 of the Last Futurist Pictures* in St. Petersburg.

Portrait of Ivan Klyun, 1913
Oil on canvas
112 x 70 cm
St. Petersburg, State Russian Museum

Malevich breaks up the pictorial components (saw, eye, clouds) and re-arranges them on illogical principles. The foreground and background are defined differently: one eye is shown on segmented planes, while the other reflects architectural elements that are located in the front on the viewer's plane.

The picture shows the elements as metallic, geometric shapes. Already in 1913, Malevich was creating art that was beyond naturalistic representation.

Square. At the end of the year, he was looking for a novel approach in radical opposition to all previous art. Over the year he principally developed two artistic strategies. At first, the pictorial area was broken up and reorganized. Composition, the representation of realistic, linear perspective, was no longer defined. Far and near were on the same plane, while distant things appeared within the close-up. The *Portrait of Ivan Klyun* was painted in 1913 and shows recognizable facial features, although the parts are segmented into different spatial planes. Surfaces are re-defined to look like bent rolled steel. The spatial disposition is illogical, pictorial depth being flattened out or extended.

During this period, Malevich interpreted the artist's work as a process of "deformation," that is "the artist's non-agreement with all previous forms, an urge towards the non-objective." In Malevich's explanation, the misshapen human forms that had appeared in Cubo-Futurist works had come about because the creative urge was not in agreement with these forms. Around 1914, the pictorial space is filled with letters and a variety of objects that are subject to no sort of logic from the normal world. The letters are partly painted, partly printed letters that Malevich had cut out and stuck on.

Englishman in Moscow, 1914
Oil on canvas
88 x 57 cm
Amsterdam, Stedelijk Museum

A cooking spoon, fish, sword, and candle are stacked in layers in front of the half-figure with the hat. The Russian characters top right mean "riding company," those below, arranged illogically, "partial darkening," a reference to the central subject matter of the opera *Victory over the Sun.* The sword in the scabbard, the hot burning candle, and moist fish can be interpreted as phallic symbols. The illogical arrangement runs parallel to the experimental efforts that were being undertaken by writers and poets.

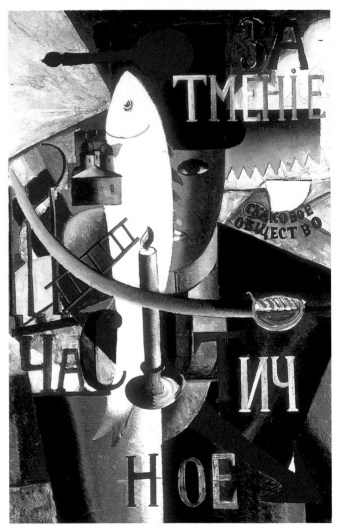

Collages and First Pure Color Surfaces

What Malevich had intuitively fore-seen was formulated in 1914. The breakthrough to the new art came after intensive experiments with the previous styles of Futurism and Cubism. In 1914, the first square or rectangular monochrome surfaces appeared within the pictorial area. These no longer were to stand in a meaningful context with the other pictorial elements present. Making elementary and monochrome surfaces

Warriors of the First Division, 1914
Oil and collage on canvas
53.6 x 44.8 cm
New York, Museum of Modern Art

Letters, thermometer, and script are all mounted. In front of them, raised in the upper center of the picture, a blue square predominates.

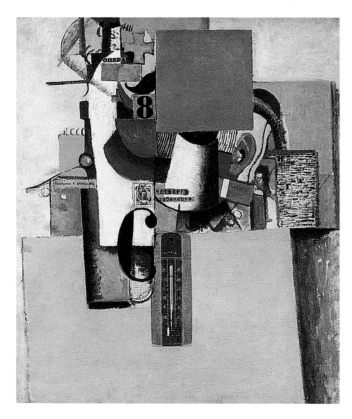

autonomous became Malevich's great invention, the origin of his non-objective art world. In this, he contrasted with the realistic represen-tations of all traditional picture compositions. He had also moved on from the stances of the western European avant-garde movements, which still clung to space and objects.

However, the monochrome squares or rectangles still form a small part of the pictorial composition. They appear most of all to be a protective shield, behind which are crowded closely-clustered set pieces from the Cubist art Malevich had left behind. Collaged features still remain, that is real objects mounted in the picture. However, they are banished into the background by the now autonomous surfaces. The blue quadrilateral in *Warriors of the First Division* effort-lessly outshines the other pictorial elements.

Optically, the monochrome surfaces point forwards. However, the back-ground is more and more strongly defined by angular surfaces. This new type of composition points to a new, non-objective world for art that lies beyond the representation of visible reality, to the objectless pictures that Malevich had painted in great number by the end of 1915.

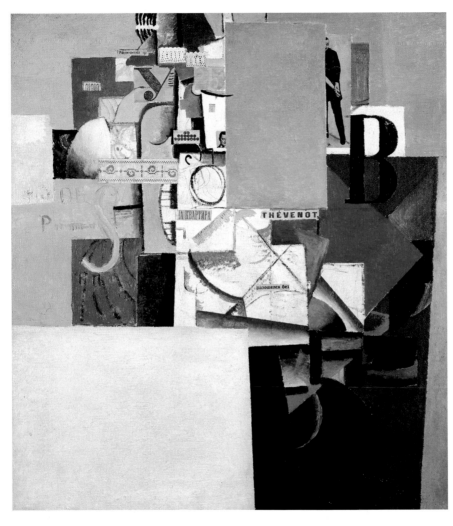

Lady by the advertising pillar,
1914
Oil and collage on canvas
71 x 64 cm
Amsterdam, Stedelijk Museum

The ground is kept flat with monochrome rectangles. Stacked in layers on them are collaged and painted elements that are indicative of Malevich's involvement with Cubism. The "lady" mentioned in the title is only a ghostly presence indicated by the hair (top left) and the figurative arrangement of blue and black. However, in front of this are pink and light brown rectangles. These shapes refer everything backwards, forming the composition or frame of the picture; elements of form replace the human figure. The picture comes together associatively in the viewer's head. Later, purely non-objective pictures by Malevich would eliminate the collaged and mounted pictorial elements.

*The "New Art" has overcome surfaces in the realm of painting, and has passed from the illusionist representation of three-**dimensional bodies** on two-dimensional surfaces, to a new method of representing **bodies and their** relationships in real space.*

Kasimir Malevich, 1923

The Mona Lisa in the 20th Century

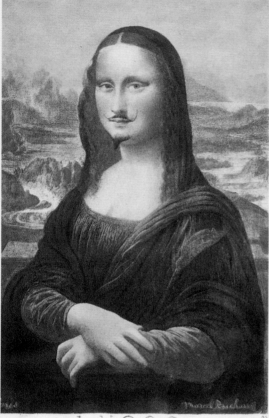

Marcel Duchamp,
L.H.O.O.Q., 1919
19.7 x 12.4 cm
Overpainted postcard
Philadelphia, Museum of
Art, Luise and Walter
Arensberg Collection

Duchamp adds a mustache
and goatee to a postcard of
the Mona Lisa. This small
intervention provokes a
whole new interpretation.
He is pointing out the
potentially androgynous
nature of the subject.

Mona Lisa, a myth
The myth of the Mona Lisa
arose in the 19th century.
Some admired the portrait
as a symbol of the "eternal
female," while others sought
to solve the riddle of the
unfathomable smile. The
painting finally became
headline news when it was
stolen from the Louvre in
1911. It turned up again two
years later, in Italy. At that
time, Leonardo's portrait
was the best-known
painting in the world, and
Mona Lisa the best-known
woman. Malevich reacted to
this glorification in his
painting *Darkness in parts*. In
the center of the picture,
beside a white rectangle, we
see a clipped, defaced
reproduction of the Mona
Lisa. Her face and cleavage
are crossed through in red.
This attack on the picture
indicates his rejection of
traditional taste in art. The
double deletion is directed
against the idealization of
this art and this femininity.
As a final piece of mockery,
he places a real cigarette in
her mouth. The Renaissance
lady is thus transformed into
a modern woman. The
discrepancy between the
modern world and the
bourgeois stylization of the
old becomes all too obvious.
Beneath her picture there is
a sign reading FLAT TO RENT.
In other words, she has to
vacate the premises so that
the new non-objective
world of free color surfaces
can move in.
In 1919, Marcel Duchamp
painted a mustache and
goatee on Mona Lisa. Under
the postcard he had altered
he wrote L. H. O. O. Q, which
we are instructed to
interpret phonetically (*elle a
chaud au cul*, literally "she's
hot in the bum"). Duchamp
was crossing out the fanciful
erotic descriptions of the
Mona Lisa and coarsely
drawing attention to the
supposed homosexuality of
Leonardo, the artistic
genius. Duchamp signed the
card on the portrait bottom
right, thus asserting the
male portrait as his own
work. For both Duchamp
and Malevich, the point was
to set their own concept of
art against the old concept.
Nowadays the Mona Lisa
has become a piece of
general property to such an
extent that she is forever
smiling at us through the
medium of advertising.

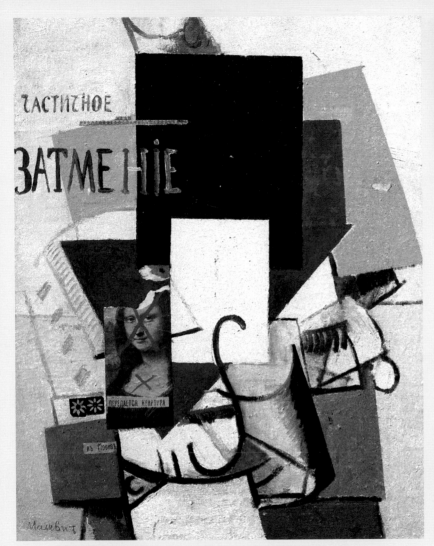

Visitors in front of the Mona Lisa in the Louvre

Darkness in parts, composition with Mona Lisa, 1914
Graphite, oil, and collage on canvas
62 x 49.5 cm
St. Petersburg, State Russian Museum

The art of the past, which was at the service of religion and the state, must awake to a new life in the pure art of Suprematism and construct a new world – the world of feeling. It seems to me that the paintings of Raphael, Rubens etc., have become nothing more to society than a concrete rendering of countless "things" that make their actual value – feeling – invisible.

Kasimir Malevich, 1927

Non-objective World 1915–1918

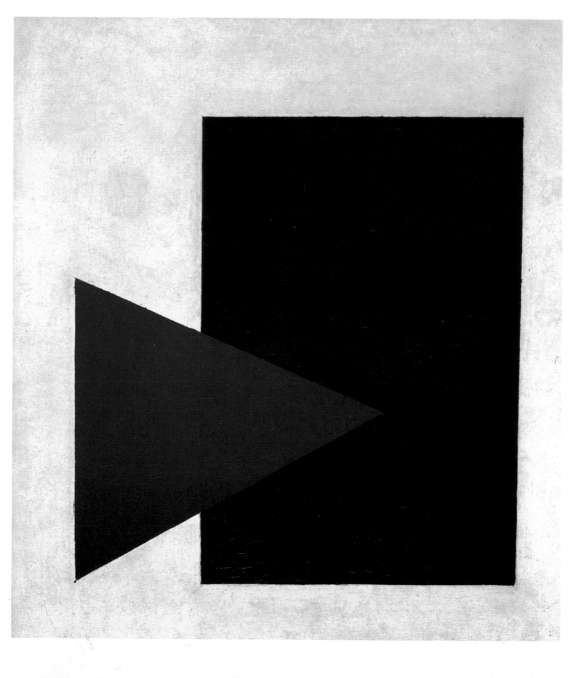

Malevich did not wish to depict reality in his pictures, or reproduce the factual and objective. He was looking for an art beyond reality, a non-objective visual world. For the artist, this non-objective world was to begin beyond academic art, which only reflects, and to go further than Cubist art, which fragments what is seen. "The Cubo-Futurists collected all objects together in the market place and smashed them to pieces. But they did not use them. A great pity," wrote Malevich in 1915/16. The non-objective world forms a system of its own. The simple form of a square forms the core cell of it, the circle and the cross the next basic elements. In contrast to the abstract art of Kandinsky, the factual is not lyrically dissolved and vaporized poetically into colored lines. Non-objectiveness is a world with both weightless and shaped, non-amorphous elements, an art from the world of the imagination.

Suffragettes in England, ca. 1914

Malevich in Matyushin's studio

1914 Germany declares war on Russia.

1915 Rasputin murdered.

1916 Battle of Verdun. Over 700,000 people killed.

1917 Tsar Nicholas abdicates and the Russian monarchy is ended. Russian Revolution breaks out, there is civil war.

1918 Gregorian calendar introduced in Russia. Tsar and family murdered.

1914 Malevich designs propaganda posters with Vladimir Mayakovsky.

1915 In December, Malevich exhibits 39 Suprematist works in the 0.10 exhibition. He becomes the leading artist of the avant-garde.

1916 Malevich and Puni give a lecture about Cubism, Futurism, and Suprematism at the Institute for Art History in Petrograd. In July Malevich is called up for military service.

1917 Enters the *Association of Left-wing Artists.*

1918 Malevich is appointed to a teaching post at the *Swomas* (Free State Art Workshops) in Moscow and Petrograd.

Opposite:
Suprematism (with blue triangle and black rectangle), 1915
Oil on canvas
71.1 x 44.4 cm
Amsterdam, Stedelijk Museum

Right:
Suprematism, ca. 1915
Pencil on paper
16.5 x 11.1 cm
Cologne, Museum Ludwig

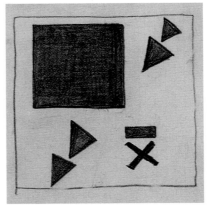

o.10 Last Futurist Exhibition

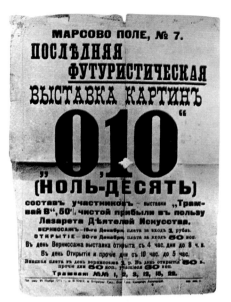

Malevich presented a total of thirty-nine non-objective works for the first time in December 1915, at the Dobychina Gallery in Petrograd. A photograph documents the arrangement of most of the works. They hung at right angles and above each other on two walls in a room of their own. Both the non-objective compositions and the radical arrangement were noticed at once. The exhibition gave rise to a rumpus, with the public reacting violently to the novel picture compositions. They were, wrote the press, compared with an iconoclasm that acted, "hurricane-like," as a purifying thunderstorm among the avant-garde: "The innovators of yesteryear are now gray-beards and are not represented at the exhibition," noted the sharp-eyed critic Alexander Rostislavov, who recognized that abstract art was already passé. What was new and innovative was "the striving to liberate painting from the yoke of nature, the purity of subject matter in painting, and the means of expression" (Petrograd, 1916). In a central position, the *Black Square* hung like a religious icon high in the corner under the light plasterwork of the ceiling. The work was slightly tilted towards the viewer, and all the other works appeared to draw on this picture, which constituted the beginning of non-objective art. In the catalog, the work was very soberly and modestly entitled *Quadrilateral (chetyryokhugolnik)*.

The *Black Square* formed the origin of Malevich's non-objective works, and was considered by the artist as his blow for the liberation of his new style. "All pre-Suprematist painting hitherto and today, sculpture, word, and music have been slaves to natural forms; they await liberation, in order to be able to speak their own language" (Malevich 1915).

Suprematism was the password for the new non-objective pictorial cosmos. The word itself did not appear before 1915 and refers to the world above, the "supraphysical reality," as pure feeling. An expression, according to the French interpreter A. Nakov in 1984, "that does not exist in Russian and which the

The Malevich room,
Petrograd, 1915

The visitor moved diagonally across the room towards the non-objective pictures, and was greeted by a display of seemingly weightless compositions with no particular top or bottom. These were a premonition of the unreal and the new. The void of the non-objective world opened up to the viewer. Malevich surprised both artist friends and the public with his Suprematist cycle of works, which had been kept secret until then.

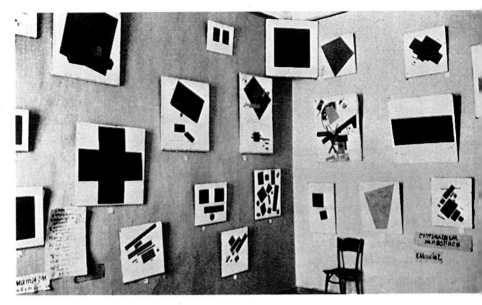

Right:
Suprematism, 1915
Oil on canvas
101.5 x 62 cm
Amsterdam, Stedelijk Museum

A meter high, the work illustrates the room proportions of the 0.10 exhibition, and in 1915 hung on the left, below the *Black Square*. The diagonal composition appears weightless, with its floating elements in the pictorial space.

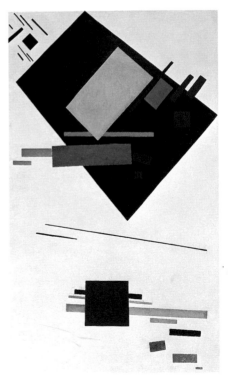

painter invented, being inspired by the language of his mother tongue, Polish."

For Malevich, Suprematism meant cosmic feeling, that is the rhythm of excitation. Everything physically real, objective, became movement, every least part of it motive power for feeling. "Suprematism has revealed that the cause of all causes derives from the idea of motion. Thus everything that we call material and surface structure is motion produced by excitation" (*Suprematism, the Non-objective World*, 1922). Motion, mobility, and dynamism governed modern life. Malevich wanted, in his pictures, to represent changing circumstances in paint.

The Black Square

When in my desperate effort in 1913 to liberate art from the ballast of objectivity I fled to the shape of the square, and exhibited a picture consisting of nothing but a black quadrilateral on a white field, critics sighed, as did society: "Everything we loved is lost. We are in a wilderness (…) We are confronted with a black square on a white ground!" The square appeared incomprehensible and dangerous to critics and society (…) and nothing else could have been expected.

Kasimir Malevich, 1927

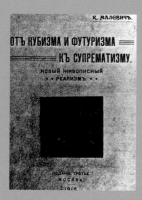

From Cubism and Futurism, to Suprematism,
The new painterly realism, title page, 1916

Malevich's brochure first appeared in St. Petersburg in 1915. The illustration shows the title page of the third impression, Moscow 1916.

The invention
"What the black square contained, Malevich did not know or understand. He conceived of it as an event so colossally important for his work that according to his own description he could neither drink nor eat nor sleep for a week," wrote Anna Leporskaya, the artist's pupil and later collaborator. The anecdote reminds us of Paolo Uccello (1397–1475). According to Uccello's wife, the Renaissance painter spent "whole nights in his studio investigating the laws of perspective." When she urged him to come to her bed at last, he just replied amorously: "Oh what a delightful thing this perspective is." The irony of the two legends is that Malevich's non-objective art wanted to oust realism and Renaissance perspective.

Black quadrilateral on a white ground
The work dates from St. Petersburg in 1915, a period of turmoil and war. In his studio, Malevich sought a vision, the phenotype of a new era. He wanted to create something that was completely different, and was in despair over his previous works of art. He looked at the canvas, his last picture, which displeased him. Boldly he picked up his brush, dipped it into the black paint and then painted over his own old composition. Approximately in the middle of the canvas he painted a black shape and covered the borders of the picture with white paint. The result is the black quadrilateral with a white frame.

The *Black Square* on a white ground could have arisen in this same way. It was a picture that in time became an icon of modernity, a vision of a new pictorial world.

Art without objects
Malevich's invention of a black, quadrilateral surface on a white field may be considered the birth of a new direction in art. The result was the first non-objective work of modern art. This extremely radical and absolutely new formulation was interpreted as a protest against the academicism and materialism of his day. *Black Square* was set against the background of naturalistic and representational art. Malevich looked on his work as a counter to practical or utilitarian art. His non-objectivist art was to him a pure act of creation, an iconoclasm against the traditional repertory of forms. The picture was first exhibited in December 1915 together with a great number of non-objectivist works. Many traces of age have developed on the painted surface, with numerous dried-out cracks visible. These allow colored particles to show through, proving that it was overpainted, this was confirmed by X-rays photos in 1990.

In 1929, Malevich painted what was the same picture again for an exhibition, indeed even making it the same size, as the original work was presumably showing cracks even then. Several painted versions and a multitude of black squares on paper have been passed down from the artist.

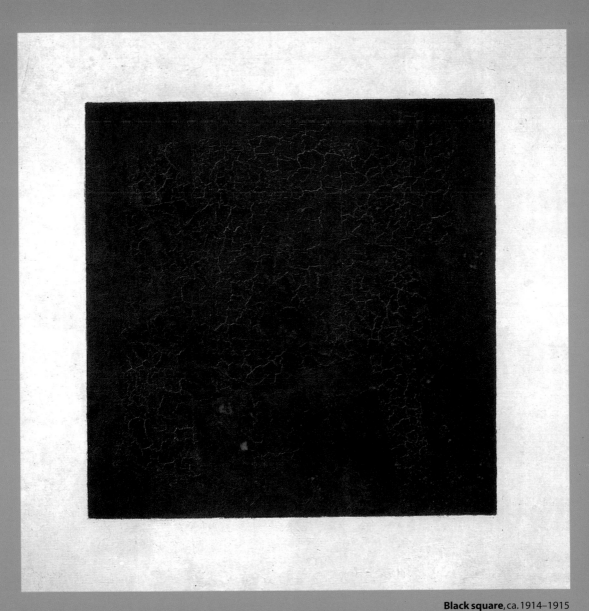

Black square, ca. 1914–1915
Oil on canvas
79.5 x 79.5 cm
Moscow, Tretyakov Gallery

Red Suprematism

"Black Suprematism" began for Malevich in 1913 with the production of the set designs for the opera *Victory Over the Sun*, while the "colored" and "white" versions can be dated to 1915 and 1918 respectively. Malevich painted black, red, and white squares as single-shape pictures (none of them are yellow, blue, green, or brown). *Red Square* was executed in 1915, and was first exhibited at the 0.10 exhibition.

The color red symbolizes both political control and revolution: "Purple stands for Byzantine power, red for the blood of the martyrs: while the Tsarist nobility wear purple as an emblem of rank, blood red is revolution, red is Communism" (Paul Kruntorad). *Krasnyi*, the Russian word for red, also means "beautiful" or "happy" in idioms. Therefore, "Red Square" also means "Beautiful Square."

Malevich's non-objective pictures can also be distinguished, according to their composition, with one or more pictorial elements. The "one-element" pictures may be allocated to static Suprematism, and the "multi-element" pictures in turn to dynamic Suprematism. All pictorial elements are shapes within the canvas and do not project beyond the pictorial fame. Artistic space remains sacred, because art was for, Malevich, a challenge beyond everyday life.

Red square. Realism in paint of a peasant woman in two dimensions, 1915
Oil on canvas
53 x 53 cm
St. Petersburg, State Russian Museum

Where the *Black Square* was a closed, contrasting form, the *Red Square* looks as if it is bursting out of its white field. The surrounding white is defined by the red, while the red leaps forward out of the pictorial field. The form is neither right-angled nor rigid, rather it displays an aggressively forceful directness. The corners of the picture pulsate outwards and the field of red looks disunified, almost like a seething, boiling mass. The title *Peasant woman in two dimensions* first appeared in an early exhibition and refers to Malevich's new concept of realism. He was searching for pictorial forms for non-objective figurations.

In 1915, everyday life in Russia was marked by war, a general strike, and uprisings. The First World War, along with the German offensive in the Baltic threatened the country. The *Red Square* by Kasimir Malevich was seen as a prototype for change. It stood for the colorful world of this life. It was a "signal for revolution," an artistic premonition of the October Revolution.

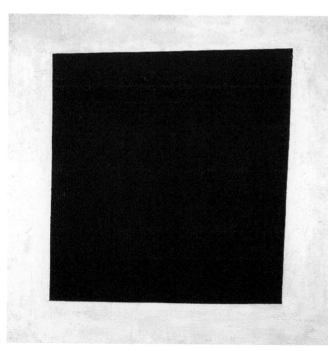

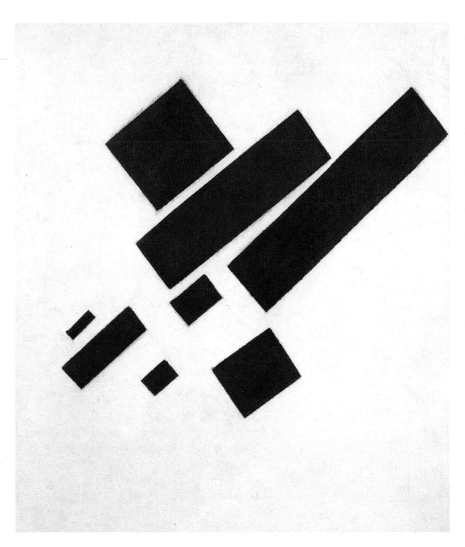

Suprematism (with eight rectangles),
1915
Oil on canvas
57.5 x 48.5 cm
Amsterdam, Stedelijk
Museum

As a consequence of the diagonal arrangement of the different-sized, visually differently weighted forms, the composition seems to float in front of a white void. The shapes themselves look like an extract from a huge construction in the heavens that is not chaotic, as in nature, but instead is clear and rectangular. The weightlessness of the composition gives an indication of Malevich's later celestial ideas for the construction of an extraterrestrial cosmos. Along with black and white, Malevich could only conceive of a "red exterior" for the floating Suprematist cities in space.

The Base Forms: Squares, Circles, and Crosses

Malevich extended art in two directions. First he created autonomous color forms, then a new repertory of forms. In the first step, Malevich was a logical painter of a development towards representing independence from natural forms. "Before 1915, neither form, nor color, nor surfaces, nor anything else existed per se," stated American Minimalist artist Donald Judd in 1974. The independence from the forms and colors imposed by nature induced Malevich to create his own formulations, whose basic elements are constituted by squares, circles, and crosses.

From the square, this "naked, unframed icon," the "zero form," Malevich derived the circle by rotation and the cross by dividing it into two rectangles and then rearranging them. The "second disintegration" of the square gave rise to the manifold forms of Suprematism, that is dynamic Suprematism.

For Malevich, the basic forms of the non-objective world symbolized "objects of feeling": in 1915, he created not "an empty square," as critics asserted, but the sensation of non-objectivity. In 1927 he wrote: "The square of the Suprematists and the forms arising from this square should be compared with the primitive strokes (signs) of early man, which, as put together, represent not

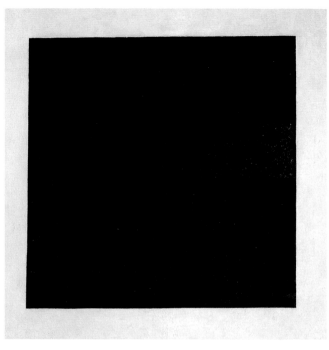

ornamentation but the feeling of rhythm. Suprematism brought into the world not a new world of feelings but a new direct representation of the world of feeling."

Malevich sees black as "the feeling of rhythm." In the opera *Victory over the Sun* of 1913, there is an anti-naturalistic passage that refers directly to the color black: "The Sun is smashed (...) / Long live darkness! / And the black gods (...) The Sun of the iron age is dead (...) We are dark of countenance, / Our light is within us." The rejection of light and enlightenment, brightness and rationalism, leads to a positive valuation of black. That is the opposite of the Christian tradition in which black symbolizes evil, darkness, and demonic powers.

Black square, 1923
Oil on canvas
106 x 106 cm
St. Petersburg, State Russian Museum

This was the first part of the three-piece group that Malevich painted around 1923. On the back, the artist signed it:"K. Malevich 1913", thereby recording the date his great invention was born as an idea. This well-known series was done in 1923 for an exhibition.

Black cross, 1923
Oil on canvas
106 x 106 cm
St. Petersburg, State
Russian Museum

Developed from two rectangles, the cross does not form an impenetrable surface but instead consists of two parts. The *Black Cross*, therefore, is not a unifying Christian symbol of redemption but instead is taken formally, as two bars intersecting. All three works in this series were painted with the students in the studio of the GINKhUK in Leningrad.

Black circle, 1923
Oil on canvas
105 x 105 cm
St. Petersburg, State
Russian Museum

The circle floats upwards to the right, thus creating – when taken in conjunction with the differently proportioned white surfaces – a composition of tension. The circle is not fixed in the middle but floats weightlessly upwards and at the same time pulsates forwards. It symbolizes the black sun, which no longer illustrates the natural cosmos but an inner excitation.

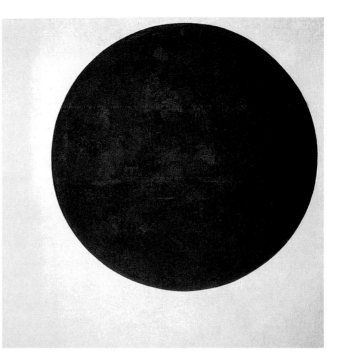

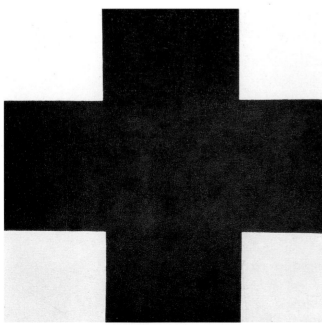

White, the monochrome pictorial background, which came as a frame, demonstrates the abandonment of perspective-based spatial sequencing. For Malevich, white was a mystic color, pure excitation. The black–white contrast shows a placing in the void, an artistic, imaginative feeling beyond utilitarian, tangible actualities. Basic non-objective forms are without content, they are pure art forms.

Dynamic Suprematism

Since 1915, dynamism and energy had defined the art of Kasimir Malevich, but he painted no fast-moving cars and flying planes, just the non-objective feeling of energy. In this, he was in harmony with contemporary scientific work, which describes matter as energy, as a dynamic balance of power of radiation. "The calculation of a material's resistance to pressure is nothing more than the calculation of its rhythmic excitation," was the opinion of Malevich in 1922. "The situation of a painter who wants to realize his work according to pure painterly, rhythmic laws is much the same."

Modern physical reality is defined by either waves or emissions. In Malevich, force fields define the pictorial space, and non-objective forms of differing sizes and color weightings build up the composition. A feeling of excitement defines the design. "Materiality is accordingly nothing but intensity of motion and scatter density. Beneath the Suprematist gaze, what hitherto seemed a catastrophic natural process is transformed into a chaotogenic 'order of elementary excitations.' For aesthetic practice, this means the artist becomes a medium. He picks up the imperatives of the cosmic waves, the thermal noise" (Norbert Bolz, 1992). Dynamic Suprematism reached boldly for the infinite: "The artist (the painter) is

Dynamic Suprematism no. 57, 1916
Oil on canvas
102 x 66.9 cm
Cologne, Museum Ludwig

The colored forms are placed in individual groups, which float weightlessly in the pictorial surface like artificial, abstract shapes of outer space.

Overcoming earth's gravity and conquering space are here foreseen by Kasimir Malevich: he depicts satellites as moons and a landing on other planets.

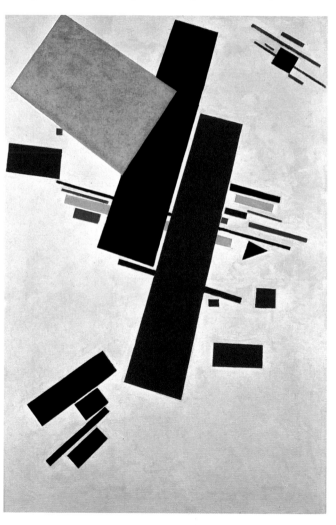

no longer bound to the canvas (the pictorial surface) and can transfer his compositions from the canvas into space," is Malevich's conclusion in his cosmic manifesto in the *Non-objective world* of 1927. The transition to architecture, the conquest of space, and the design of an architecture of outer space, are proclaimed.

Art and technology, the artist and the engineer, will shape the new world. The engineer is the one with a practical relationship with the world, but his truth "cannot be anything but practical, as its world of practical expediencies is further honed to perfection every day." The engineer directs his thoughts "at future perfection, the neutralization of gravity, and amendment of yesterday's weight distributions, and is constantly creating new rules of distribution" (Malevich, 1922).

The artist, however, strives not only after improvements (from handcart to carriage, to railway to plane) but is much more concerned to find absolutes; only art creates perfection.

In Malevich's view, the Constructivists, with Rodchenko and Tatlin, profaned art's absolutes and immortality in mundanity and politics.

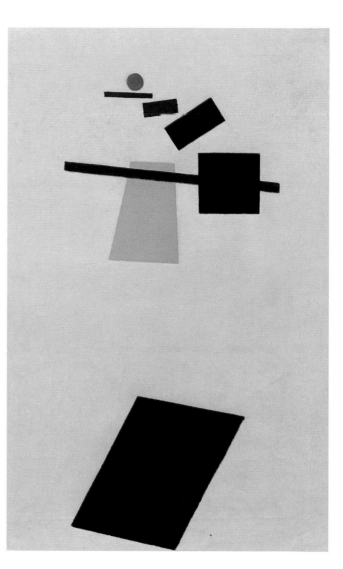

Suprematism. Realism in paint of a football player, 1915
Oil on canvas
69.9 x 44 cm
Amsterdam, Stedelijk Museum

Above and below have become relative. Malevich indicated as much in the way this picture was hung in various exhibitions. Initially (late 1915) the picture was hung with the large black shape at the top. In 1991/20 and the Warsaw exhibition in March 1927, the black form was to be seen at the bottom. A few weeks later, in Berlin, it was placed at the top once again.

El Lissitzky, Thinker and Designer

El Lissitzky was one of the most versatile artists in the Soviet Union. He was a trained architect, and he soon endeavored to unite all areas of art. He was a painter, graphic artist, typographer, photographer, architect, and writer on art in one. After the October Revolution, he became a member of the state commission for art, which gave him a great deal of influence on the development of cultural policy in the Soviet Union. From 1919, he taught, together with Malevich, at the academy in Vitebsk. Through the influence of Malevich, he became familiar with Constructivist principles of design. He arranged geometric colored surfaces and bodies in the picture, so that they developed a dynamic spatial effect. In the painted visions of space, the connection between art and architecture was to become manifest. These non-objective space–time images were to give expression to the idea of Socialism. Lissitzky subsequently called the works *Proun*. "Proun is the interchange station from painting to architecture," he wrote in 1924. *Proun* was a neologism made from "Pro" and UNOVIS. UNOVIS, which means "innovators in art," was a group that was founded by Malevich. It brought together students who wanted to follow Malevich down the road to non-objective art. Most of them studied with both Malevich and Lissitzky, who ran the printshop. Lissitzky's extension of Suprematism into space also had, in turn, an influence on Malevich, who began work in Vitebsk on Suprematist models of architecture. For Lissitzky, unlike Malevich, what was important was the link between art and politics. He wanted to be one of those shaping the developing Soviet Union. Along with countless designs for posters and book illustrations, this principally took the form of architectural designs for the *Lenin Tribune* and his *Wolkenbügel*, or skyscraper substitutes. As artistic freedom became more and more restricted by Stalin, he left the country for Germany in disappointment.

Stalin demanded that art propagate unambiguous, realistic, and ultimate truths. Lissitzky, in contrast to this, represented the view that "every form is the momentary image of a process … Thus the work is a stopping place in a genesis and not a solidified principle."

In Germany, he made contact with the Bauhaus, where similar ideas were represented. After he became ill, suffering from tuberculosis, he remained in Switzerland for two years before returning to the Soviet Union. He was awarded a professorship in interior design. From 1928 onwards he began work on the design of the Russian exhibition pavilion. In the same year, he created a photomontage frieze that was approximately eighty feet long and twelve feet high for the International Press Exhibition in Cologne. This monumental work brought him international recognition. He worked untiringly until his death in 1941 on presenting an avant-garde face for the Soviet Union through its exhibition pavilions.

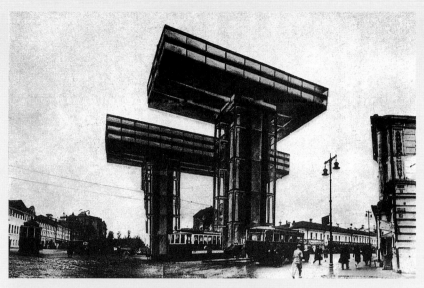

Left:
Wolkenbügel in Nikitsky Square in Moscow, photo montage, 1924.

Wolkenbügel was Lissitzky's answer to the skyscrapers favored in the Soviet Union. It was the counter-image of the American model of skyscraper, which climbed vertically into the sky. A horizontal structure is raised on long steel supports. The three monumental supports carry a glass, wedge-shaped three-story building. The supports were to serve as "traffic shafts". Having a minimal ground footprint, the designs appear to float. The materials of steel and glass, and the floating effect, are expressions of the buildings' modernity. This architecture clearly derives from crane construction, which was seen as the ultimate in engineering. The buildings stand far above normal building height and rise majestically above the townscape. A total of eight *Wolkenbügel* were to be built along the former ring road around the center of Moscow. They were to be oriented to the Kremlin, and were themselves to act as points of orientation. No structure of this sort has ever actually been realized.

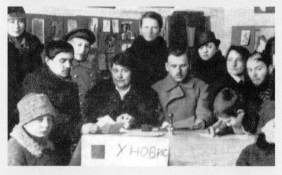

The UNOVIS group, photo, 1920

El Lissitzky is visible on the far right. Malevich is to be seen second left.

Right:
Hit the Whites with the Red Wedge, 1919
Poster
48.3 x 58.5 cm

This poster of 1920 was Lissitzky's reaction to the Soviet-Polish War. He charges Suprematist formal language with political meaning. The elongated red triangle stands for the Red Army, smashing into the white circle of the enemy.

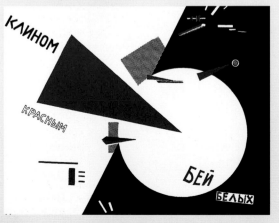

The Teacher and Philosopher

"One must work for the good of the community," Malevich wrote to Matyushin after he was named chairman of the national commission for art in 1917. He worked tirelessly for reforms at the academies of art. A year later, he was appointed to the newly founded State Art Workshops in Moscow and Petrograd. He ran the workshop for textile design and thus became involved in applied art. The following year, he went to the art school in Vitebsk, which was headed by Chagall. Here he established the UNOVIS or "Innovators in Art" group. This was a sworn circle that opposed academicism. New teaching methods were introduced, a particularly revolutionary one of these being working in groups. The "innovators" saw one of their most important objectives as the reshaping of ever-

Malevich at GINKhUK, photo, 1925

Malevich stands in front of teaching panels he designed himself. Among the various subjects he touched on, he relates the history of painting to his concept of Suprematism. His closest students listen to his lecture with concentration. He was considered a prophet of his art. Malevich had a great influence on many of his students, and he took them with him into his non-objective world. In 1926, the school was closed as it was viewed as politically intolerable.

yday reality. To achieve this, they painted trams and printed posters and signs which they hung up in Vitebsk. "I arrived in Vitebsk after the October festivities, but the town still blazed with Malevich's decorations – circles, squares, dots, and lines in various colors," recalled a visitor. "It was like arriving in an enchanted city."

In Vitebsk, Malevich first published his theoretical writings on art. The publications were designed by Lissitzky and printed in the college printshop. In 1924, Malevich became director of the Museum for Artistic Culture in Leningrad formerly Petrograd, which was transformed into a state institute for art, or GINKhUK. The aesthetics department for the theory of form was his personal fief. A large part of the UNOVIS group had gone with him to Leningrad. Unflustered by growing political animosity, he continued to teach the idea of Suprematism. Using display panels he put together himself, he elucidated the development of art. His pupil Anna Leporskaya confirmed that the "rigorous system and method of teaching art (...) also expanded [our] understanding of older art."

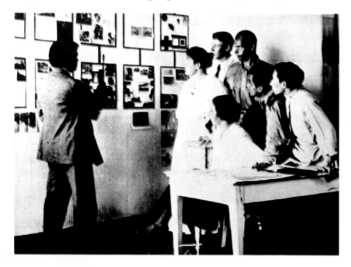

Suprematist mural by the UNOVIS group, photo, 1920, Vitebsk

For the revolutionary festivities, the UNOVIS group took over a façade of a building. The entrance to the building is crowned by a large Dynamic Suprematist mural. Between the windows of the ground floor are various versions of a triangular, circular, and rectangular overlay. Suprematism had gone public with the intention of penetrating society.

DIE MAHLEREI

DIE STRUCTUR DER MAHLEREI

DIE FARBE

DIE STRUCTUR DIE FARBE

Display panel no. 8, 1927
Amsterdam, Stedelijk Museum

In this panel, Malevich combined pictures from both the past and the present. The development of painting and color was to be elucidated. The center spot is occupied by a self-portrait by Cézanne and the *Red Room* by Matisse. They are the central figures and, at the same time, they were Malevich's early models. His history of art began with his contemporaries and looked back from that point.

Below:
Ilya Chashnik,
Suprematist relief,
ca. 1922/23
Oil on wood
111.8 x 111.8 x 7 cm
Cologne, Ludwig
Collection

In his painting,
Chashnik adopts the
genre of a relief, a
sculptural picture.
The configuration of
volumes with its
sundry prominences
is very reminiscent
of Suprematist
architectural models,
while the balancing
clarifies the striving
after harmony in
non-objectivism.

Ilya Chashnik,
anonymous photo

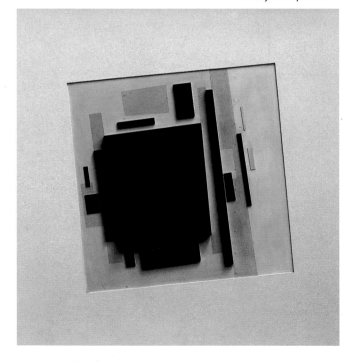

Chashnik and Suetin – Pupils of Malevich

Ilya Chashnik and Nikolai Suetin were the closest pupils, and later colleagues, of Malevich. Seventeen-year-old Chashnik, an optician by profession, and the twenty-two-year-old aristocratic Suetin, previously a soldier, entered Lissitzky's studio in Vitebsk in 1919. After Malevich also started teaching in Vitebsk that year, both quickly became part of his innermost circle. Chashnik was the driving force of UNOVIS, Malevich designating him the "loudspeaker" of the Suprematist concept. He was responsible for the periodicals and manifestos of UNOVIS, which he printed in Lissitzky's printshop. Suetin concentrated more on the applied aspects of Suprematist art. Both were convinced that artists must allow the principle of harmony to flow into everyday life.

In 1922, they followed Malevich, before his appointment as director, to Petrograd as assistants. Even in Vitebsk they had begun to design architecture on Suprematist principles, and it was on this that they now concentrated on at the new GINKhUK school. Although Chashnik and Suetin worked closely with Malevich, and their works were exhibited under the UNOVIS group name, they did not simply copy their teacher. They used the "Suprematist alphabet" of surfaces

and forms as Malevich had shown in his works and theoretical writings, but modified it according to their own intuition.

Chashnik painted very frequently on a black ground, which was an inversion of Malevich's white base. Contrasting colors turned the black background into an energy field. Chashnik also created Suprematist reliefs, which expressed the Suprematist concept spatially. Although Chashnik died in 1929 of appendicitis, he left behind a legacy of original Suprematist work.

Suetin introduced Suprematism into applied art. As an employee of Petrograd's porcelain factory, where he became artistic director in 1932, he designed every part of a service in a different way, although this was avoiding the industrial standardization necessary for production. In addition to his, he designed furniture and exhibition architecture. When Malevich died in 1935, Suetin built him a green Suprematist coffin and designed the tombstone with a black square. This ensured a final fling beyond the grave for Suprematism and Malevich's self-assertion. In 1937, Suetin was made responsible for the interior furnishing of the Soviet pavilion at the world exhibition in Paris, which gained him an international award. He remained in charge of Soviet exhibition designs until his death in 1954.

Nikolai Suetin, **Chair**, 1927
Pencil on paper
12.2 x 7.6 cm
Cologne, Museum Ludwig

In 1927, the *Drevtrest* or society for the woodwork industry, organized a furniture design competition in which Suetin took part. In his drawings of desks, sofas, shelves, tables, and chairs, he takes influences freely from Suprematist ideas. The pieces were to display new forms and harmonious color solutions. The designs of the furniture should result directly from function. They were made up of surfaces, squares, and cubes. In part, they are strongly reminiscent of the architectural models that Suetin had designed jointly with Chashnik and Malevich. Thus, his chair is made up of rectangular surfaces. Even the back of the chair shows no rounding to match the human shape. It appears as the pure essentials of a chair, which, because of its reduced form, could stand anywhere.

Below:
Nikolai Suetin, anonymous photo

World System

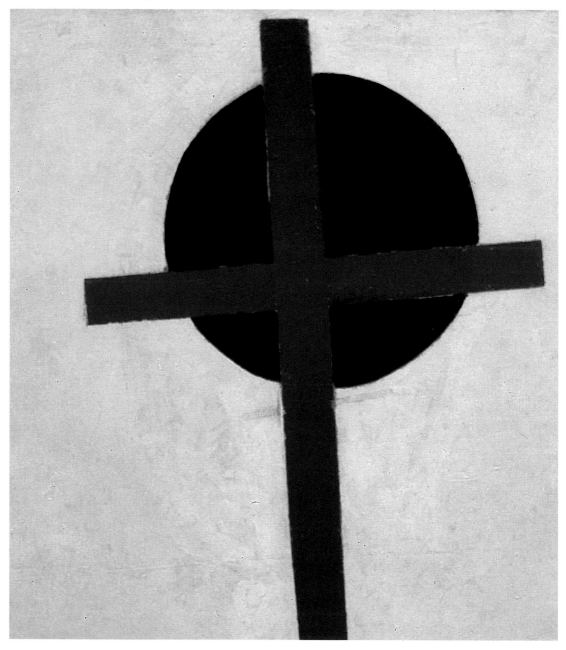

After the black and red phases, in 1918 Malevich developed a third phase of "white Suprematism" to formulate universal social and cosmic concepts. According to Malevich, the color white strives for totality, for a paradisically pure condition of immateriality: "The White Square is the key to the beginning of a new classical form, a new classical spirit." Malevich seemed to foresee the magnitude of his impetus. The human spirit should "henceforth attain a new dynamic excitation that is realized in Suprematist forms, in the Suprematist classicism of non-objectivity." Suprematism became a system of visionary force. Exhilarated, the artist called for the new age to start: "I have broken through the blue lampshade of color restrictions and have gone over to white. Soar after me, Comrade Aviators, into the unfathomable. I have erected the signal masts of Suprematism (...) Free unfathomability, infinity lies before you."

Mahatma Gandhi
ca. 1920

Kasimir Malevich
ca. 1920

1919 Prohibition in the USA (until 1933).

1920 Russian civil war, between the anti-Bolshevist White Russians and the "Red Army."

1920 Suffrage of women in the USA. Mahatma Gandhi begins his non-violent fight for an independent India.

1922 Founding of the Union of Socialist Soviet Republics – the USSR.

1924 Death of Lenin.

1927 Trotsky is expelled from the Party by Stalin.

1918 Malevich designs the sets for Mayakovsky's play *Mysterium Buffo*.

1919 He teaches at the art school of Vitebsk, directed by Marc Chagall, who is succeeded in 1919 by Vera Yermolayeva.

1920 New teaching methods introduced in Vitebsk.

1927 Malevich criticizes Socialist Realism. Members of UNOVIS are expelled from the school. Malevich leaves Vitebsk and takes over as head of the Institute for Artistic Culture (GINKhUK) in Leningrad until 1929. Travels to Warsaw and Berlin. Visits Bauhaus in Dessau, where he meets Walter Gropius.

Opposite:
Suprematism, detail, 1921–1927
Oil on canvas
72.5 x 51 cm
Amsterdam, Stedelijk Museum

Right:
Suprematist satellites, 1920
Lithography
in: *Suprematism, 34 Drawings*, Vitebsk 1920

White on White

Malevich painted the Suprematist composition *White Square on White* to be both the zenith and at the same time the end-piece of the one-figure pictures. That was to mean his last stage of non-objectivity: "Here, in its center of excitation, the dynamism of motion has reached the uttermost limits, where it must vaporize."

A balance was set between white and nothing: the tension of contrast is transformed into meditative repose as inner tension. Concentration not on life, not on the everyday, not on things but instead on feelings. Malevich's rejection of direct reality creates energy for Utopian imagining. White Suprematist art balks at the misuse of agitation. It could not be transformed either into a revolutionary template or an ideological pointer.

In 1918, Malevich pondered on the universe: "The blue of the sky is overwhelmed and pierced by the Suprematist system and has gone over into white as the truly real incorporation of infinity, and is therefore free of the colored background of the sky" (1919).

In the following year, El Lissitzky, who was his colleague at the art school in Vitebsk, published a slender volume called *Suprematism. 34 drawings*, with lithographic drawings and a text by Malevich. In it, he describes the conquest of the universe by new kinds of machine, an "aeroplan" that is not "of sheer catastrophe design" with an internal

Suprematism, 1918
Oil on canvas
97 x 70 cm
Amsterdam, Stedelijk Museum

The diagonally angled white form is reminiscent of the Orthodox double cross or an airplane.

Belief and technology are each explored associatively, but it is motion, dynamics, that triumphs. The result is a spiritualist work that takes on cosmic dimensions without rejecting modern times in so doing. This is a provocation for artists who believe in Communism. They do not understand that only through an Utopia does earthly misery seem soluble.

combustion engine, but can fly "thanks to certain magnetic interrelationships." This "Suprematist machine (...) will be homogeneous and without any suspension (...) every constructed Suprematist body will be enclosed in a natural organization and form a new satellite per se; we need only to find the interrelationships between two bodies operating in space. Earth and moon – between the two, a new Suprematist satellite equipped with all elements can be constructed that will move on an orbit where it cuts its new path." The interpretation of this is that Suprematist reality reaches for the stars and thereby creates an artistic heavenly body.

White Suprematism became all-embracing and transformed objective nature, so that it was no longer a mere theatrical set but became a new reality. Suprematism of the third kind "is on the way to white non-objective nature, to white excitations, white consciousness, and white purity as the highest stage of every condition, of repose as of motion." In the conclusion of the Vitebsk manifesto of 18 February 1922, the artist noted the strategy of redemption: "Man's path must be liberated of all objective junk. (...) Only then will it be possible to perceive the rhythm of cosmic excitation. Then the whole globe will be embedded in a shroud of eternal excitation, in the rhythm of the cosmic infinity, of a dynamic silence." As prophetic as the tone, was the surprising accuracy of the forecast with regard to the profane,

sober, digital information world of cyberspace, where texts and pictures have become global and immaterial, as extraneous streams of data. It is an interesting coincidence that the transforming power, electricity, was called "white coal."

White square on white, 1918
Oil on canvas
78.7 x 78.7 cm
New York, Museum of Modern Art

The combination of white on white offers no contrasts, and admits neither aesthetic nor mystic ideals. The inner shape is slightly tilted, in this way it communicates a floating weightlessness. The *White Square* appears neither in front nor at the back, but hovers as nothing in nothing.

Suprematism as Total Art

Malevich included the applied arts in the all-embracing design plan of Suprematism. As early as 1917, he exhibited objects such as cushions, bags, and clothing with Suprematist embroidery at an exhibition for arts and crafts in Moscow. Even his mother is supposed to have knitted from his drawings with Suprematist patterns. While his pictures encountered bafflement, the clothes and bags apparently enjoyed great popularity. Malevich viewed clothing as a surface for the presentation of artistic compositions, with the assistance of which he intended to assert the idea of Suprematism.

In the euphoria of the October Revolution, many artists took part in the shaping of the "new world." They equipped numerous demonstration marches, rallies, and festivities. Malevich himself decorated, among other things, the first May parades that occurred in 1918. Many of his colleagues went into production in order to get to know the world of the workers. Artists and engineers were to unite in a single career. However, this was not the path taken by Malevich. He stuck firmly with the pure notion of Suprematism. While Tatlin, for example, designed workers' clothing that was to have practical application, Malevich was concerned always with the aesthetic dissemination of his artistic ideas. Since his

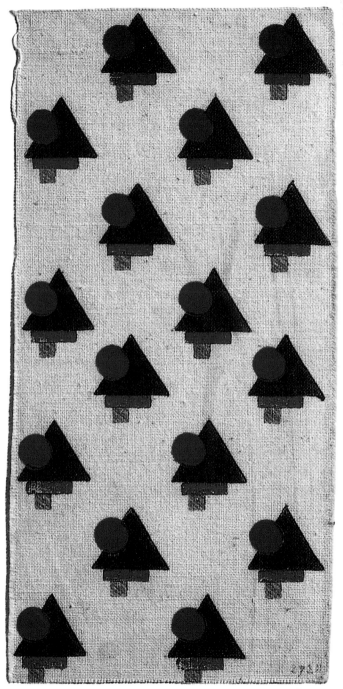

first professorship at the academy of art, he had produced designs for fabrics. He did the drawings, but did not himself enter the factories. Like his pupil Suetin, from 1923 onwards he also designed china for the Petersburg porcelain works. A new, more modern design was required. However, materials were in short supply, and all that resulted was a design that was strongly orientated on Malevich's architectural ideas. Instead of developing new designs of china, existing plates and cups were provided with Suprematist motifs. Malevich's ambition was for these new, non-objective forms to permeate throughout Soviet everyday life. However, the china was made in such small runs that the majority of it was actually sold abroad as collectors' items.

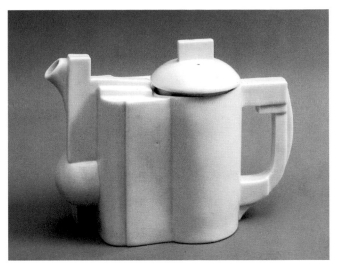

Opposite:
First fabric with Suprematist pattern, 1919
St. Petersburg, State Russian Museum

Geometric forms in various colors are overlaid in this, the first Suprematist fabric design.

Below:
"Suprematism" cups, 1923
7 x 12.5 x 5.9 cm
St. Petersburg, State Russian Museum

The round cup design is interrupted by a flat side. The half-cup sets the sculptural against user expectation. Both the flat and the round sides have Suprematist compositions, which were designed by Malevich's pupils, Suetin and Chashnik.

Above:
Teapot, 1923
Porcelain, glazed
18.2 x 22.3 x 8.3 cm
St. Petersburg, State Russian Museum

Malevich's teapot bears witness to a sculptural conception of the form. The architectural feeling is enhanced by the white materiality. He splits up the object in a Cubist manner and recomposes both the round and flat, rectangular forms. In this way, he liberates the teapot from its unambiguously utilitarian nature. At the same time, the form is reminiscent of a steam engine.

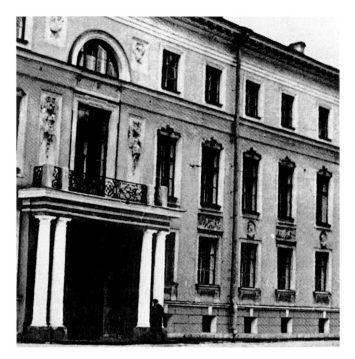

Teaching Experiments and Creativity

1919 was a decisive year for Kasimir Malevich. As the foremost member of the avant-garde in Russian art, he was an unchallenged leader. In April, he showed his white pictures at the state exhibition "Non-objective creation and Suprematism," held in Moscow. In the fall, he was invited to the art school in Vitebsk, where he taught until 1922. According to contemporary reports, he appeared there like a prophet preaching to students the doctrine of Suprematism.

In Vitebsk, Malevich embarked on his great teaching experiment, changing the small place into a hotbed of artistic creativity. Together with El Lissitzky, he expanded his two-dimensional approach into architecture of cosmic dimensions. His quest was for the "free flight of forms," and no longer for the struggle between color forms.

With his colleagues and students he became politically active. In 1920, the Vitebsk Suprematists founded the UNOVIS group (advocates of the New Art), whose members included Malevich, El Lissitzky, Vera Yermolayeva, and Nina Kogan. New teaching methods were tried out, most notably group work instead of academic instruction. For Malevich, the UNOVIS group became a sort of modern monastic community. The elite were

Myatlev House, Leningrad, photo
This building housed both the MKhK and the GINKhUK and was also Malevich's flat.

UNOVIS group, Vitebsk, photo, 1920

1st row: M. Vexler, V. Yermolayeva, I. Chashnik, L. Khidekel;

2nd row (l. to r.): Chervinka, Malevich, J. Royak, N. Kogan, N. Suetin, L. Yudin, Margaril

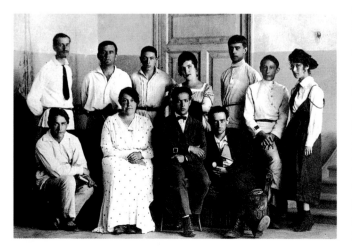

gathered together beneath the symbol of a black square. This led to interesting collaborations, but to tension with colleagues as well. This led to Marc Chagall leaving his beloved Vitebsk, where, until his quarrel with Malevich, he had been director of the art school. The first signs of erosion of Malevich's leadership of the avant-garde were becoming visible. The inhabitants and authorities in Vitebsk did not understand the non-objective festive decorations, and further activities were banned as a precaution.

At the end of 1919, the theoretical work *On the New System in Art* appeared. This was Malevich's opening salvo as a teacher at the

Suprematist composition, 1916
Illustration for the Bauhaus book, 1927

Malevich sought ways to represent the celestial without actually copying religious models. The boundlessness of space and the void are demonstrated here by depicting a few objects floating in the distance.

Malevich among his students, members of UNOVIS about to leave for Moscow, photo, 1920, Vitebsk.

Standing among his students and colleagues, Malevich holds a Suprematist plate and points to a banner. El Lissitzky is seen top right (with a bald head), while several students have sewn black squares on their clothes – the badge of the Suprematist artistic and social community.

Vitebsk art school. Instead of practising painting, Malevich expounded the main currents of modern art: Cézannism as the geometrization of nature after Impressionism. For him, Cézanne was the creator of a new painting surface (facture), and Cubist design was a liberation from the object through multiple perception. The dynamic representation in Futurist painting represents time visually: "Even if academicism is considered as communication of an act, it is clear that Futurism has found the way to a more complete and complex form of expression for the sum of motor energy of the city. The energy and dynamics of cities like Moscow, Berlin or New York will be the future measure of the tension protrayed there."

Gotha architekton,
ca. 1923
Plaster
85.2 x 48 x 58 cm
Paris, Musée nationale
d'art moderne, Centre
Georges Pompidou

This architekton was
reconstructed in Paris
from descriptions and
photos. Out of sixty-
nine elements, forty
parts were newly
added. The skyscraper
is, compared with
those of Russian
contemporaries,
sober in concept,
without adornment
and pomp and not
a monument, in
the Stalinist
confectionery style,
for a Socialist hero.

Architekton 1926
This historical photo
shows one of
Malevich's models.

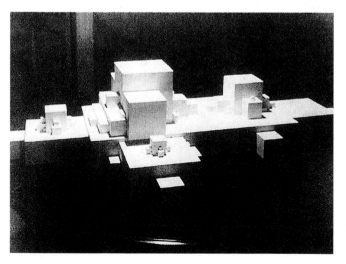

Spatial Suprematism

From 1918–1920 civil war raged in Russia, with the Red Army ranged against the anti-Communist troops. Art as well as artists were radicalized: "There can be no talk of painting in Suprematism. Painting has long been abolished, the artist himself is a prejudice of the past." With these words, appearing in the 1920 Vitebsk manifesto, Malevich denies both his own development and that of art. In the UNOVIS manifesto of 1924, Malevich proclaims his opening towards architecture: "Consciousness has surmounted surface and has advanced to the art of spatial design." Painting pictures was henceforth left to those who, despite great efforts, could not liberate themselves from two dimensions. Their thinking was flat because they could not overcome surface.

Together with El Lissitzky, the professional architect, he developed an ensemble of three-dimensional bodies, which were called *architektona*. The basic form is the cube, and cubic shapes were added to each other, aggregated horizontally or vertically. Three-dimensional Suprematism communicated visionary shapes as models for buildings in cosmic space. They become "planets," flying architecture of outer space that was reminiscent of the double-decker planes of the time. The weightless white shapes are part of his revolutionary pedagogic concept of

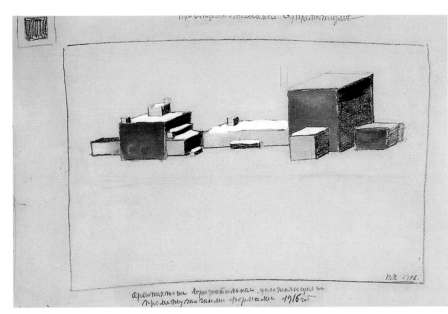

Spatial Suprematism, 1916
Gouache and pencil on paper
36 x 54.5 cm
St. Petersburg, State Russian Museum

From above only white surfaces are visible, from the front only red and from the side only black cubic surfaces. The colors define the rigorous formal design of this study for Suprematist architecture.

Suprematism. It is an art that does not refashion everyday objects but instead changes daily life as a productive artistic force, permeating all areas of life as a total work of art.

In the workshops in Vitebsk, there were no academic distinctions with regard to the students. Work on the "interchange station for architecture" (Lissitzky) was done jointly. The architectural/three-dimensional work formed the basis for practical, earthly work, for revolutionary structures. The experiments were in the same context as, for example, the dynamic tower for the Third International by Vladimir Tatlin or Chashnik's project for a Suprematist tribune. All of these works were part of the developing international style of the 1920s, which were evolving parallel to the inventions of the Bauhaus in Dessau or the De Stijl group in Holland.

Malevich at an exhibition in the Russian Museum, photo, 1933

Malevich was head of the experimental laboratory in the State Russian Museum in Leningrad and showed Suprematist and post-Suprematist works in an exhibition called "fifteen years of Soviet art". The *Red Cavalry* and his architectural models were on show here for the first time. The negative reception given to the exhibition resulted in few of the works being shown at the Moscow stop of the exhibition.

However, Malevich carried on thinking and left "architectural Suprematism to young architects," while he himself pushed on in the intellectual sphere, attempting to expound what could be "perceived in the infinite space of the human skull."

Vladimir Tatlin

Like Malevich, Tatlin also broke new ground in art. In 1913, he exhibited his first counter-reliefs. These were artistic objects made of wood, glass, and metal that no longer depicted, anything. They are considered the first non-objective sculptures in the history of art. They juxtapose surfaces and curves, and real and imaginary space. Tatlin's creed was to show "real materials in a real space." With this, he founded the artistic movement known as Constructivism.

After the October Revolution, Tatlin designed the *Third International Tower*, a masterpiece that was never realized.

All over the country, awe-inspiring bronze monuments were being erected in honor of deserving revolutionaries. Tatlin opposed this, wanting to create an emblem of the Soviet Republic with his Constructive modern language and technology. Carried on a wave of euphoria, he went to the factories to learn the craft of the engineer. Industrial production and art were to unite for the benefit of society. He designed an energy-saving oven and work clothing that was both light and warm. By abandoning the free, "useless" realm of art he became the opposite extreme to Malevich. Whereas Malevich placed Suprematism above the new socio-theoretical society, Tatlin represented the view that art should serve society. Despite their differences, both fell victim to the changing cultural policies of the late 1920s. Tatlin returned to conventional painting, working, until his death in 1953, mainly as a designer of stage sets.

Biography

1885 Vladimir Tatlin born in Kharkov.

1898 Aged 13, leaves his parental home to go to sea as a ship's boy. Later employed as a casual worker in workshops of icon painters and stage-set designers.

1909 Graduates from the Moscow School of Painting, Sculpture, and Architecture. Many of his early works are concerned with the subject of seafaring.

1911 Designs the stage sets for the play *Emperor Maximilian*, which is performed in artistic circles.

1913 Travels to Berlin and Paris. Visits Picasso's studio.

1915 Establishes his own artistic style, initially known as Tatlinism, then Constructivism. He sets up his own workshop, which attracts numerous pupils. After the Revolution, he becomes head of the Moscow Institute of Art.

1917 Does the décor of Café Pittoresque in Moscow, which becomes the meeting place for Moscow's artistic and theatrical world.

1919 Head of the department of painting at the VKhUTEMAS School of Art in Moscow.

1922–1927 Appointed professor at the GINKhUK in St. Petersburg. Director of the Material Culture department. When the GINKhUK is closed in 1926, he is appointed director of the Theater and Film Department in Kiev, where he works until 1927.

1929–1932 Works on the bird-like *Letatlin* flying machine.

1931 Awarded the title of "Artist of Soviet Union", and one year later the only one-man show in his lifetime takes place.

From **1933** onwards, exposed to massive criticism. He is accused of blatant and particularly damaging formalism. He returns to painting objectively, and retires as a consequence of the attacks.

1934 Returns to painting stage sets. He stays with this profession until his death in 1953.

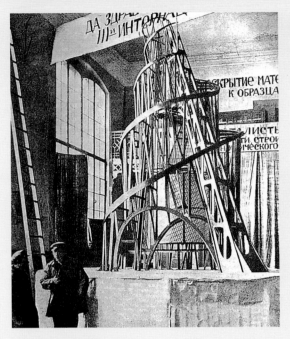

Vladimir Tatlin, **Revolution tower**, photo, 1920

Tatlin's tower was an attempt to create a new kind of monument. The Communist International was not just to be celebrated but was also to be accommodated in the interior.

The first model was 23 feet high. The sculpture was to be a 1,300-foot design of glass and steel, thus it would stand higher than the Eiffel Tower. Two contra-rotating spirals circumscribe a conical volume. The angle of the latticework corresponds to the curve of the Earth. In the center, a tower made of various geometric bodies was to stand inside the outer tower. Along with executive organs of the Communist International, a propaganda center was also to move in here. The building was intended to rotate, as the first dynamic monument. Cosmic ideas are linked with modern materials, which stand for the construction of Socialist society. At the same time, sculpture and architecture were to come together in a new unity.

Vladimir Tatlin, **Corner counter-relief**, 1914
Burnished iron plate, copper, wood, cords, anchoring elements
71 x 118 cm
St. Petersburg, State Russian Museum

Tatlin creates a sculpture from wood and metal plate, which he sets up in the corner of a room with the help of ropes. The sculpture projects into the room like a bridge construction, and at the same time includes the room as a part of its own logic. The everyday materials that are used no longer depict anything, but are defined by their tensile structure.

Lenin, photo, 1920

Vladimir Ilyich Lenin was chairman of the Soviet Council of People's Commissars. In this photo, which looks like a press photo but is carefully composed, he is shown in one of his typical poses, at the rostrum. However, the picture is posed: Lenin is not speaking.

Pavel Kusnetsov, **Long live the Revolution**, 1967
Oil on canvas

Lenin is shown as the leader of the Revolution borne along by a crowd. His face is framed by a red flag. He has raised his arm as if to speak and at the same time points the way. The crowd is striving to the left, against the direction of reading. This creates the impression that it will have to struggle but is unstoppable. This is a typical heroic image in the style of Socialist Realism. Lenin and, at the same time, the Revolution also are to be glorified. As leader of the Revolution, Lenin is borne along by the masses, but he also shows the way. Many such pictures were created after his death. They present an idol to the masses and served Stalin's propaganda. The style was forced through against the avant-garde.

Art and Politics

As many artists did after the Russian Revolution of 1917, Malevich believed in a convergence of the new political and cultural eras. The People's Commissary for Educational Matters, Lunacharsky, was a highly educated and liberal man who initially supported the artists. He defended them against Lenin, whose notion of culture was traditional and conservative. Lenin was only interested in easily understandable art, which could be used to stir up the masses. When he instructed artists to use antiquity and 19th century realism as their guide, Malevich reacted with several essays, which defended the new and revolutionary in art. Even in the early 1920s, he foresaw that politics would demand that artists subordinate themselves to Socialism. Malevich also reacted negatively to Lenin's demand for monumental sculptures for revolutionary heroes.

Although the situation was becoming visibly more difficult, until Lenin's death, art had a certain freedom. Four days after his death, Malevich published a thirty-page tract in which he called for Lenin not to be made into a secular state saint. Nonetheless, Stalin pushed through the absolute veneration of the revolutionary leader. In the following years, Malevich's influence waned increasingly. Before his dismissal from the Institute of Art History in Leningrad in 1927, he wrote the director a letter that reflects his disappointment with

politics. "People who from the very beginning of the October Revolution have tirelessly developed their work – not from fear but from enthusiasm – are now excluded." After Stalin finally forced through his dogma of Social Realism ("Back to Realism, forwards to the Masses") in the early 1930s, Malevich's work remained locked up in Soviet museums until 1962, when it again could be seen.

Kasimir Malevich, photo ca. 1932

Below:
The Red cavalry, 1928–1932
Oil on canvas
91 x 140 cm
St. Petersburg, State Russian Museum

Three mounted squadrons, their riders as red as their horses, stand out against a distant horizon. It is a magical, unreal "Red Army" that Malevich here allows to pass before our eyes.

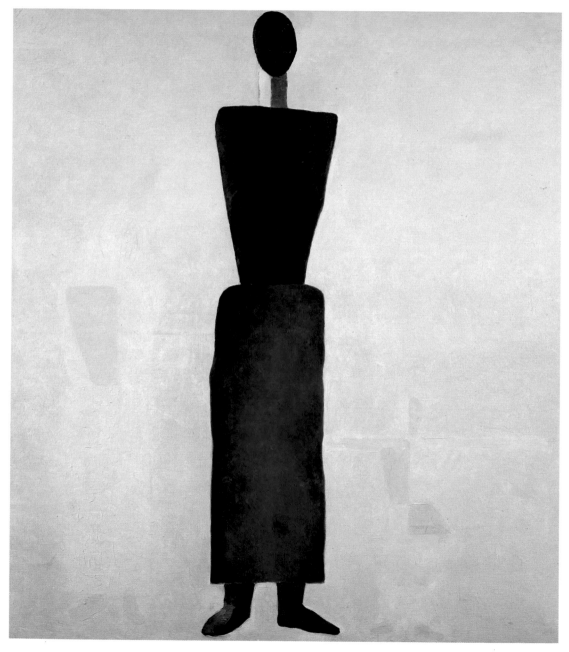

In 1924, Lenin died; the state and the economy became instruments of Stalin's autocracy. Art itself became a medium of propaganda, politics prescribed graphic realism. Malevich returned to painting and portrayed pictures of objects. The late works pick up elements of the Impressionist style of the early works, which makes dating them difficult. Nonetheless, in the last years, there are works of Suprematist rigor and simplicity as well as works with critical representation: peasant figures with arms raised in a cross, or stigmatized heads reminiscent of Christ's Passion; armless peasant figures whose bodies appear strapped in straitjackets. In 1929, the murderous collectivization of agriculture began in the USSR. In the final years, Malevich painted many portraits in which the severity of Orthodox icons is combined with the sovereign likenesses of the Renaissance period.

The Chrysler Building is opened

Malevich ca. 1927

1927 Canberra opened as new Australian town.

1929 Wall Street crash (Black Friday), world economic crisis lasts until 1933.

1930 Chrysler Building (sixty-five stories) opened in New York.

1933 Hitler becomes the Chancellor of Germany.

1935 Beginning of the Great Purge in which Stalin liquidates his opponents.

1927 Trip to Warsaw and Berlin. *The Non-Objective World* appears. The work is intended to introduce German artists to Malevich's artistic philosophy.

1929 Expelled from Art History Institute in Leningrad. Retrospective in the Tretyakov Gallery in Moscow.

1930 Malevich interrogated, spends three weeks in prison.

1932 Decree made, dissolving all artistic groups.

1935 Malevich dies of cancer in Leningrad on May 15. His corpse is taken to Moscow. The funeral urn is interred at his dacha near Nemchinovka.

Opposite:
Suprematism. Female figure, 1928–1932
Oil on canvas
126 x 106 cm
St. Petersburg, State Russian Museum

Right:
Figure with arms outstretched, forming a cross, 1933
Pencil on paper
36 x 22.5 cm
Cologne, Museum Ludwig

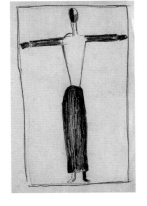

Figures Make Their Comeback

Head of a peasant (with black beard),
1928–1932
Oil on canvas
55 x 44.5 cm
St. Petersburg, State Russian Museum

The bearded head stands in front of a monochrome blue sky. The facial parts are without individual features, empty and obliterated. It is fairly obvious why Malevich's pictures were no longer exhibited in Russia after 1933. The censorship was aimed at eradicating painted criticism of politics. Those encouraged and promoted were academic artists comfortable with easily digestible "Socialist Realism." The official artistic taste of the dictators favored handsome-looking, athletically built, positively radiant Soviet people of the industrial generation. These officially applauded, approved pictures preached "agitation for happiness." Malevich, in contrast, impresses with his archaic composition and formal rigor.

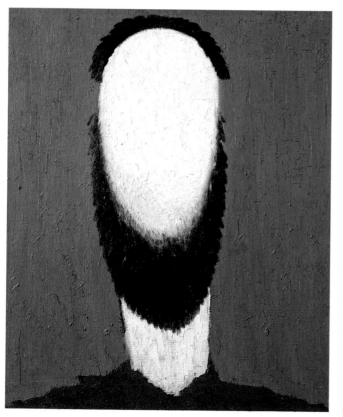

Malevich did not come from a peasant family; his father was, in fact, a factory worker. Nevertheless, he grew up in rural Ukraine, and throughout his life he remained in contact with the peasant world through his art. Even in his Suprematist period, he gave the subtitle *Realism in paint of a peasant woman in two dimensions* to *Red Square* (1916).

From 1928 to 1932, he painted a series of pictures concerned with the world of peasants, either full frontal figures or icon-like heads. These figures do not deny the Suprematist primacy of color detached from objects. This is not realism with natural coloration; it is much more a stylized, almost religious representation of simple agricultural workers in front of an abstracted nature. These pictures of simple monumentality recall Old Russian icons, only here they depict not saints but instead simple peasants.

Many of these paintings conceal touches of political criticism. Since 1929, agriculture had been forcibly collectivized so that the backward (as the Communists saw them) kulaks could be modernized, to transform Russia into an industrial state. We recognize figures with anonymous, obliterated faces, stigmatized figures with markings in their faces, and cross-shaped figures, or others that lack both arms as if they were confined in straitjackets (see ill. p. 74).

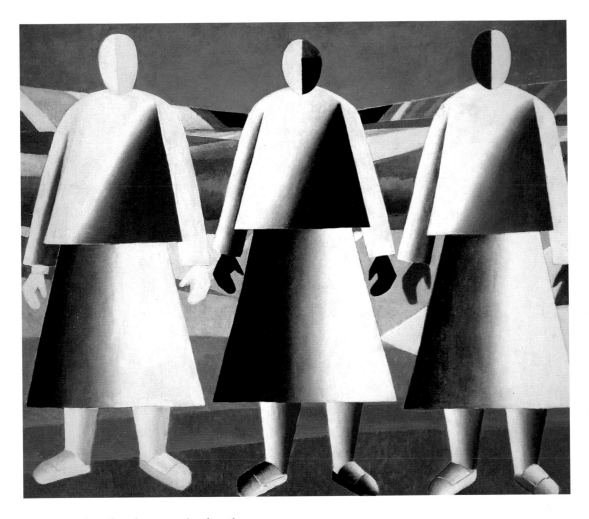

For Malevich, the comeback of the figure was not a denial of Suprematist painting. The works are not narrative, and they refuse to have anything to do with either the state-ordained pathos of the workers, or petty-bourgeois Social Realism.

Girls in the field,
1928–1932
Oil on canvas
106 x 125 cm
St. Petersburg, State Russian Museum

Placed frontally in a row, the three female figures stand looking menacing. Yet, due to their similar stances, they appear to be apparently intimidated into a neat line, as if chained to each other by the wrist. The colors are pure, not mixed, and no similar colors touch between the figures and the background. The fields that are cultivated by peasants are made up out of bright strips of color that are placed together. Nature and naturalism are distant in this non-objective and Suprematist composition with human figures.

Trip to Berlin, 1927

On March 8, Malevich traveled to Berlin. It was his aim to publicize the ideas of Suprematism beyond the Soviet frontiers. He stopped en route in Warsaw, to present his pictures in the Hotel Polonia.

Then, at the end of the month, the art critic Tadeusz Peiper accompanied him to Berlin, also interpreting for Malevich, who spoke no German. When they arrived in Dessau on April 7, they discovered that vacations had begun on the previous day. Thus, Malevich was only able to meet Gropius and Kandinsky. While lunching with Ise and Walter Gropius, it became apparent to him that there was no chance of his getting a professorship at the Bauhaus. Probably he had hopes in

Kasimir Malevich and Tadeusz Peiper in Berlin, photo 1927

Grand Berlin Art Exhibition (May 7–September 30, 1927), photo

This was the first time that Malevich had had a comprehensive show of his works in Germany, presented in a room of their own at the Grand Berlin Art Exhibition. Along with his pictures, he exhibited his architectural sculptures as well. He hoped that, with the help of lectures, he could popularize his theory of non-objective art in western Europe.

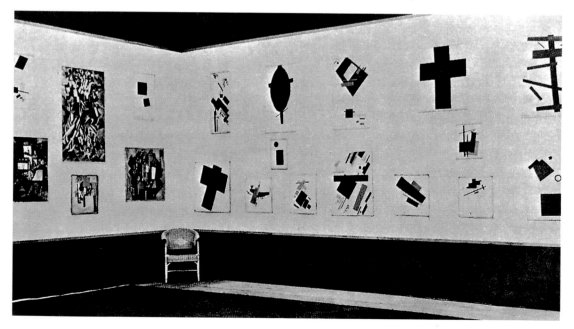

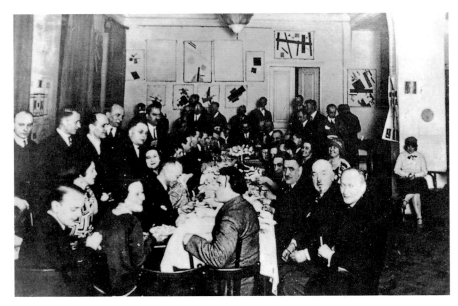

Festive banquet,
photo, 1927

The first stop on Malevich's tour was Warsaw, where he exhibited some of the works he had brought along in the Hotel Polonia. On the opening day of the exhibition, the Polish Artists' Club organized a great welcome celebration in his honor. The festivities took place in the same room as his exhibition. Malevich is sitting in the place of honor at the head of the table.

that direction, because his scope for work in the Soviet Union was becoming ever more restricted.

It was nonetheless agreed that Malevich would be able to publish his Suprematist theory in a Bauhaus publication. The design was taken over by László Moholy-Nagy, and the book appeared at the end of the same year. A month later, during discussions of his exhibition, it emerged that it was not just financial reasons that prevented Malevich being offered employment at the Bauhaus. With the support of the Association of Progressive Berlin Architects (The Ring) he was given a room of his own at the Grand Berlin Art Exhibition. Originally his display panels were to be installed here as well. As the texts for these were in bad German, however, Malevich had to dispense with them.

The Bauhaus artists accused him of Romanticism. Malevich's ideas of a free art resting on pure feeling could not be reconciled with the Bauhaus notion of uniting art and technology. The same argument was repeated as with the Russian Constructivists. When he returned to Leningrad in disappointment, even before the exhibition had actually finished, Malevich left both his manuscripts and his pictures behind with his Berlin friends. During the Nazi period, the pictures were hidden and thereby saved.

The Fate of His Works

Malevich (left) with students in front of the main entrance to the Russian Museum, photo, Leningrad 1931

In 1927, while still in Berlin, Malevich received disquieting letters from Russia about political changes. Critics were being thrown out of office by an all-powerful state, expelled from the Party, and subsequently exiled from Russia. Art itself was to be directed and nannied by the state. Malevich decided, nonetheless, to go back. At the end of May he appeared at the von Riesens,

his host family, with a thick, bound packet. "With a solemnity not normal to him, he asked us to keep the packet until he returned. He hoped to come back in summer 1928. If he did not manage to and if they did not hear from him in the next 25 years, the packet could be opened," Hans von Riesen explained in the foreword to the writings of Malevich, edited in 1962. Malevich traveled back east. He left behind in the west not only his writings, but also his architectural models, his art teaching panels, and the pictures shown at the Berlin

exhibition. This trip was Malevich's first and only visit abroad. He did not leave the Soviet Union again. In the young Soviet state, conditions were also getting worse for artists. Malevich's manuscripts were rejected. In an exhibition in 1929 he was presented as a "bourgeois artist", and decried in the press as a formalist. He was still teaching, giving lectures, and taking part in exhibitions, but the photos taken at the time show a resigned artist. In 1929, the dictator Stalin railroaded through a five-year plan to turn Russia into

a modern industrial state. Forced collectivization of agriculture liquidated thousands of peasants. Encroaching state control demanded further victims. Political opponents were systematically exterminated in purges. In 1932, the Soviet state dissolved all artist groups. Henceforth, all artists were combined into a state-controlled institutional association.

In the event of my death or irremediable loss of freedom, and in the event that the possessor of these manuscripts should have the wish to publish them, he must study them thoroughly and then translate them into another language because at that time I was under revolutionary influences and so considerable conflicts [contradictions] could arise with the form of the defense of the art that I now represent in the year 1927.

Kasimir Malevich, May 30, 1927

The fate of the works

Dictatorships in east and west, and the Second World War made it impossible for the modern thinking of Malevich, Mondrian, and the Bauhaus to continue to find favor. After the exhibition in Berlin in 1927, Malevich's works remained in Germany, being first temporarily stored by a transport company, then moved to a museum in Hanover. In 1935, some works were bought by Alfred Barr Jr., director of the Museum of Modern Art in New York. The head of the museum in Hanover, Alexander Dörner, could, however, neither exhibit nor store the works, as Nazi policy was either to confiscate, sell, or destroy modern art. The remaining works were taken to the architect Hugo Häring in Berlin, who had been the curator of the Berlin exhibition in 1927. He kept the works safe until 1943 in Berlin, then after that in his house in Biberach. It verged on a miracle that the major part of the panels, models, and paintings (except for a dozen or so large-format works) survived the war. In 1951, Willem Sandberg tracked them down in Biberach and acquired them for the Stedelijk Museum in Amsterdam. Due to this coup, Holland now possesses the greatest collection of Malevich works outside Russia. The bundle of papers that Malevich entrusted to Gustav von Riesen before his return to Russia were discovered in 1953 undamaged in the cellar of a bombed house.

Above:
Malevich exhibition at the Stedelijk Museum, Amsterdam, photo, 1989

The first international Malevich retrospective after the Second World War toured Leningrad, Moscow, and Amsterdam.

Left:
Malevich in front of his works, Leningrad, photo, 1924

Late Compositions

On the other side of the picture entitled *Complex presentiment* of 1928, Malevich wrote: "The composition is made up of a feeling of emptiness, loneliness, and the hopelessness of life." He dated the picture back to 1912, which gave it the appearance of a past diary entry and not that of a commentary on the current political situation. This was to protect himself. Yet we come across criticism of the political situation in the painting itself. He painted abstract landscapes with and without figures. The landscapes are made up of colored horizontal strips whose coloration corresponds to that of Dynamic Suprematism. The rough structure of the pictorial surface manages to match the huge fields depicted. Both in the landscapes as in the peasant pictures, Malevich deals with the pictorial subject matter Stalinist policy wanted, but in his manner of representation he adheres to the tradition of modern art. Malevich picks up the rural tradition of folk art and attests, thereby, to his closeness to the peasants and their culture. This drawing on tradition is many years away from the naturalistic pictures of the modern agriculture that Soviet power was forcing on the peasants. Malevich painted many of these strip landscapes, some of which are endowed with figures or houses. The houses look just as lost as the peasants, expressing a sense of deracination and destruction by enforced modernization.

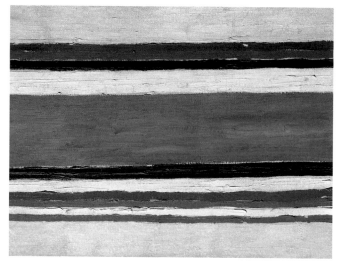

Above:
Composition,
1928–1932
Oil on canvas
40 x 56 cm
St. Petersburg, State
Russian Museum

The composition is made up of horizontal stripes of different colors. In the middle a broad green stripe dominates, enclosed by a lower black and an upper white stripe. Although the picture is actually an abstract composition, it is still able to be read as a landscape.

Below:
Malevich, photo, Leningrad, 3.4.1933

The picture, *Girl with a red pole*, is receiving finishing touches, although it already framed. The young woman resembles his sister-in-law, and this is probably a late family portrait.

Red house, 1932
Oil on canvas
63 x 55 cm
St. Petersburg, State
Russian Museum

A solitary house is standing in a landscape made up of colored stripes. The colors of the house and the stripes match the palette of the most reduced Suprematist pictures by Malevich. The red rectangle and coloration are quotations from his non-objective pictures. On the roof of the house are three chimneys. There are neither windows nor doors. The house cannot be entered, nor is it conceivably occupied. It stands there sullenly like a monolith. Within the calm, rhythmically articulated landscape, the house looks alien and disturbing. As a town building, it does not belong in the country anyway. Thus two different cultures encounter each other. The disturbing urban element is placed in the rural landscape and destroys it. The picture can thus be seen as a reference to the forced collectivization of Soviet agriculture.

A last change of direction in Malevich's art came in 1933, when he took up the painting of portraits once again. He portrays the sitters with ceremony, as reposeful individuals, in the manner of Renaissance antecedents.

Self-Portrait as the Painter Prince

After attaining classical proportions and relationships, the new Suprematist order was granted the right to life and development, not only in the works of Kasimir Severinovich. Here, a link came into the line of art that is quasi-unfinished in the stormy development of Suprematism. This is the "figurative" art that brought Malevich back to Nature, to portraits, and the real environment.

Anna Leporskaja, 1971

Self-portrayals

Self-portraits first featured in Italian Renaissance painting in the mid-15th century, coinciding with the growth in the power of princes and burghers, and the diminution of Church supremacy. The pictures reflect a change in artists' self-confidence. They no longer see themselves as artisans but as creators. Although self-portraits are primarily depictions of the painters, they are also self-examinations. They are the artists' way of finding out about themselves. It is no accident that a mirror is required for a self-portrait. As with every portrait, the result must resemble the sitter and, at the same time, reveal his character. The painter shows himself as an individual as well as an artist. The most famous self-portraitist is Rembrandt, who did more than one hundred pictures of himself. With the invention of photography, realistic portraits visibly lost their importance, so that 20th-century examples are rare.

Albrecht Dürer

The last of the three self-portraits by Albrecht Dürer dates from 1500. It is the best known and most striking of his self-portraits. He presents himself full frontally, in front of a black background, as was customary in the Early Renaissance. Dressed in a fur gown, he points at himself with his right hand, as if to say: "This is me." The emphasis on the eyes and hand highlight the artist's "tools", while the valuable gown pronounces him to be an established burgher of Nuremberg. Dürer's long, curly hair and the frontal pose are reminiscent of pictures of Christ. The artist appears like an image of God. Although God is the creator of the world, the artist comes second as the creator of works of art. This is where the new self-assurance of the artist becomes most evident. With the appearance of his monogram on the left and his name written out to the right of the head, he appears three times in the picture.

Albrecht Dürer, **Self-portrait in fur gown**, 1500
Wood
67 x 49 cm
Munich, Alte Pinakothek

The painter prince

One of the last pictures by Malevich is a self-portrait. He paints himself half-length in front of a white background. The black background of Early Renaissance portraits, which also features in contemporary portraits by Malevich, is exchanged for a white one. This is a reference by Malevich to cosmological Suprematism. He paints himself within a realm of freedom. He is dressed in fantasy clothes whose upper part adopts the colors and forms of Suprematism while the lower is reminiscent of Renaissance dress. Even the headgear is borrowed from Renaissance pictures. The red of the biretta, which is picked up in the Suprematist shoulder part and the borders of the sleeves, lends his dress unity.

While the body appears frontally, the head is turned slightly to the viewer's right, so that Malevich's gaze glides past into an undefined distance, thus indicating a point of reference known only to him. We look at him from below, so that the painter is looking over our heads. The viewer's gaze is also directed upwards by the upturned thumb. The hand gesture has a multi-layered meaning. Although the thumb points to the artist, the fingers point in a line that intersects the line of the artist's gaze outside the picture. The reference to something external, something invisible to the viewer, is thus strengthened. The gesture can also be

interpreted as seigniorial. With the reference to Renaissance art, Malevich presents himself as a painter prince. He thereby emphasizes his claim for artistic freedom, an art that stands above and outside of the Stalinist doctrine of art. The viewer must look up to him, while he himself moves in other intellectual fields. That this is still Suprematist art is indicates by the signature in the bottom

right of the picture, which consists of a *Black Square*.

Self-portrait, 1933
Oil on canvas
73 x 66 cm
St. Petersburg, State Russian Museum

The Death of a Suprematist

Illness and death

In 1933, Malevich was diagnosed as having cancer. He died in May 1935 at the age of 57 in the presence of his mother, wife, and daughter. Leningrad City Council assumed the funeral costs. The deceased lay in state in the Artists' House, then was accompanied by a long procession of pupils, friends, and colleagues to the station, from where he was taken by train to Moscow. There he was cremated and buried near Moscow. Today a cube of white concrete, with the "front square covered in crimson" (Hans Peter Riese), serves as a monument to the artist and his epoch-making invention. It was erected by Moscow artists in 1989. In 1935, Suetin designed a "white wooden cube with a black square, which in time fell apart" (Riese).

In 1934 and 1935, the works of Malevich were exhibited for the very last time, after which they disappeared into museum vaults until 1962. It was not until 1977 that they were officially incorporated in to the collections held by various museums.

Above:
Malevich on his deathbed, photo, 1934

Beside the bed of the critically ill painter are (right) his mother and (left) his wife and daughter. In front is Anna Leporskaya.

Below:
Suprematist coffin, photo, 1935

Lying in state, photo, 1935

In the background, Malevich's late works and the *Black Square*.

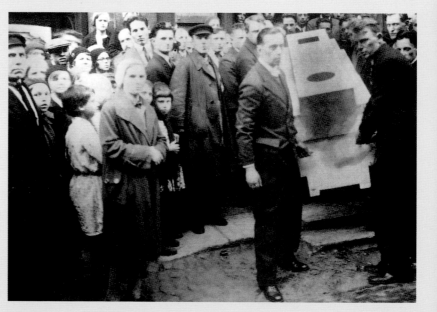

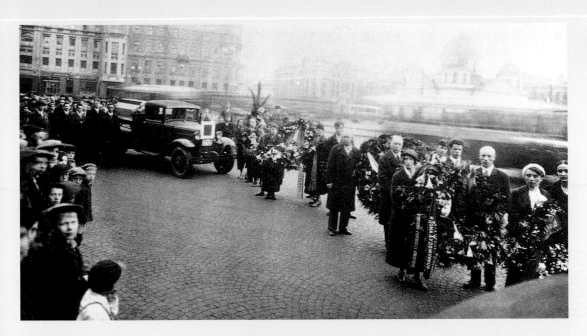

The coffin containing the body is carried to the station on a truck, photo, 1935

The funeral procession was described thus by R. V. Velikanova, a contemporary employee of the GINKhUK. "The procession passed along Nevsky Prospekt to Moscow Station. We walked in front of the open hearse carrying wreaths in pairs (…) At the end of the train was a goods wagon bearing a small white sign: K. S. Malevich."

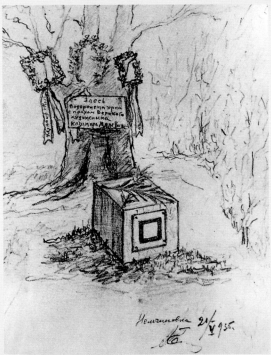

Left:
Design of the tombstone, 1935, Drawing

The inscription on the tree says: *Here lies buried the urn with the mortal remains of the great artist Kasimir Malevich. Nemchinovka, 21.5.1935.*

Below:
The gravestone, photo, 1935

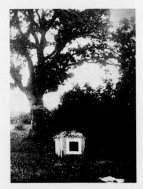

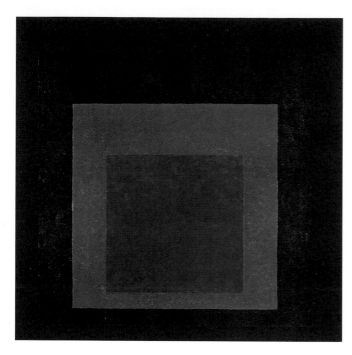

The Square – an Emblem of Modern Art

Malevich's epochal invention was works of art in which color and form become autonomous and the color surface, in other words the *facture*, acquired intrinsic value. The form of the square, invented in 1913, became a symbol of modern art, the archetypal image of a rational language of art. The square as an elementary base form of non-objective art constituted, and still constitutes, a challenge for many artists, and is the occasion for many a work of art.

Many artists expanded Malevich's ideas on color form into independent works. Art after the 1920s, with "unism" (Wladislaw Strzeminsky, Katarzyna Kobro), the exiled Bauhaus artists (László Moholy-Nagy, Josef Albers), geometric and concrete art (Friedrich Vordemberge-Gildewart, Erwin Heerich, Max Bill), right up to Minimalist art (Donald Judd, Carl Andre, Sol Lewitt and Robert Morris) saw, in the reduction of form and the serial multiplication of squares, an art that became a partner of modern development without being a mere dull adaptation of the Zeitgeist.

"To open the eyes," the concrete experience of seeing, and art as "a spiritual document of life" – both stances formed part of the philosophy of Josef Albers, who was born

Below:
Josef Albers:
TOG 79, 1964
Oil on canvas
45.7 x 45.7 cm
Private ownership

Above:
Josef Albers, **Homage to the Square**, 1966
Oil on canvas
65 x 65 cm
The Hague, Haags Gemeentemuseum

Combination and variation take central position in the *Homages to the Square* which were begun in 1949, and in which subtle modifications of color values are investigated. Albers's homages illustrate his color experiments. Over 1,000 variations were done on this topic. These color experiments elucidate illusionist spatial effects. The interposed color surfaces display different depth positions within the pictorial area. They can be considered as precursors of Op Art painting.

in 1888. From 1933 onwards, he taught at the Black Mountain College in North Carolina (USA), having previously taught at the Bauhaus in Weimar and Dessau. A reduction in artistic means and precision in expression were what underlay his motto "simplicity in multiplicity." From 1950, Albers taught at the art school in Yale, finally dying in 1976.

The American artist Sol Lewitt (born in 1928 in Hartford, Ct.) studied art in New York, and created his first sculptures in 1962, using pure geometric forms. These plain sculptures redefine the room in the museum of art. They lie on the ground without a base. Around 1965, their size burst open the traditional gallery with its walls of pictures and shocked traditional habits of seeing. The existence of these sculptures becomes relevant only in the room and through the room. The elegantly smooth object takes the room's intrinsic value and redefines it as a dimension of rational sculpture. Such works with a minimal artistic content were described by the art critic, Richard Wollheim, as a new style of art he called "minimal art." This plain art surprised visitors to galleries of the time, who were accustomed to very expressive art or brightly colored, advertising-oriented Pop Art. The new Minimalist style of Carl Andre, Dan Flavin, and Donald Judd presented artificially created works that aimed to be no more than pure, emotionless objects.

Sol Lewitt,
Modular Cube
(Cube B), 1969–1983
Aluminum, coated white
428 x 428 x 428 cm
Düsseldorf, Konrad Fischer Galerie

These works were designed by the artist but assembled from either machine-made or factory-made components. The directly personal touch, which constitute the subjective artistic message, is missing, the prime importance is the design of the room. Sol Lewitt works with pre-determined forms, such as squares or cubes. The procedure is conceptual. Rational worlds of ideas become sculptures. Possible variations, of modular multiplicity, color, and material, are played through in a systematic manner. Rational ideas and concepts achieve new, perceptual, spatial experiences as real three-dimensional works: "Conceptual artists are mystics rather than rationalists. They leap to solutions which are excluded to logic." (Sol Lewitt, 1969)

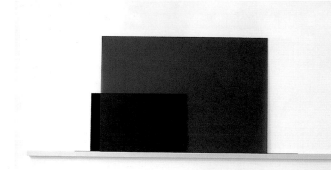

Squares in Current Art

Malevich's radical invention is still flourishing in present-day art: the *Black Square* continues to both confuse as well as provoke artists into critical consideration and enlarge their repertory of forms. In the world of the elemental, visual insights acquire interest because form and color are not used narratively for illustration. Three artists of three generations are presented here in the illustrations on this page. Each of them found his 'voice' in confronting the simple rectangle.

The youngest is called Peter Krauskopf, who was born in 1966. A resident of Berlin, he exhibits two colored sandblasted Plexiglas panels, which are arranged on a horizontal bar. Of different sizes, the panes are not fixed and can be shifted to produce different gray values and formal proportions. In either, it provides a box of aesthetic bricks. Depending on the walls and also the way the light falls, the work can be optimized in the given situation in the room. The viewer is actually drawn into the aesthetic process.

Gerhard Merz was born in Munich in 1947, but lives in Berlin and Italy. In 1989 in Zurich, the artist exhibited a large double square, which is at least one hundred square feet in size on a blue-gray wall coloring, thus creating in the Zurich Kunsthalle a museum-piece, spatial ensemble of rational and aesthetic modernity. For

Above:
Peter Krauskopf,
No. 8, 1998
Synthetic material and aluminum
75 x 189 cm
Private ownership

This mobile piece can be altered by the viewer.

Below:
Gerhard Merz,
Construire, 1989
Ivory black pigments, brass frames, marble bench
Squares 228 x 228 cm each
Exhibition, Zurich, 1989

The work consists of a double square of deep black pigment paint framed in brass. The marble bench is placed for meditative contemplation.

Ellsworth Kelly, **Black and White**, 1992
Enamel and mixed technique on wood
528 x 518 x 5.1 cm
Realisation Jeu de Paume, Paris 1992
New York, Matthew Marks Gallery

The work shows a black and a white square. They only touch at one point, and they lie on an imaginary diagonal. Both of the squares are separate, forming an entity in the wall composition. Ellsworth Kelly demonstrates a reposeful and yet tense encounter. The white square and the black square remain autonomous. They are so placed that there is no dominance, but they are mutually dependent.

Gerhard Merz, art is not a free or liberating play of forms. The artist must complete and refine the material and proportional imperatives of the arrangement. Aesthetic works of cool precision and architectural severity are created, which sublimely address the feeling of modernity.

Ellsworth Kelly was born in 1923 in New York state, where he still lives. The artist changes the traditional context of form and ground, that is that of the *Black Square* and white overlay. A form no longer stands in front of a background, indeed, the form is liberated from the background. A relationship of subordination is abolished, ground and form acquire equal status as independent works. These forms constitute a new relationship through their proportion and arrangement on the wall.

Glossary

abstraction Disregarding naturalistic or depictional rendering to the point of completely dispensing with objective representation.

avant-garde [Fr.'vanguard'] A term for artistic groups or forms of artistic expression in advance of their time, pointing the way forward beyond what exists, and anticipating trends.

Bauhaus [Ger.*Bau*, construction, and *Haus*, house] A school of architecture and design founded in Weimar in 1919 by Walter Gropius in order to encourage the different arts to work both together, and with crafts and technology. It was established from 1925 in Dessau, from 1932 in Berlin, and dissolved in 1933. School resumed in the USA as the New Bauhaus.

Classic Modern A term used in art history for the early phases of abstract art that began with Cézanne and has since become classic in its modernity.

collage [Fr.'glue together'] A picture made of elements stuck together, partly or entirely using everyday materials. These objects bring reality into the work of art. Two-dimensional canvases become ready-mades, or montages.

complementary colors Colors opposite each other in the color circle or color triangle, which when mixed add up to white or by subtraction produce black. Examples are red/green, blue/orange, yellow/violet.

composition Formal construction following defined principles of arrangement. Principles of composition may include the relationship of color and form, symmetry/asymmetry, movement, rhythm, etc.

Constructivism A concept formulated around 1913 by Tatlin to describe art that has broken away from all objectivism and endeavors to construct technical, rational structures with geometrical, abstract forms.

contour The outline of a form painted as a line or evoked by color contrasts.

Cubism Style developed by Pablo Picasso and Georges Braque from around 1907 in which objects are no longer shown according to their optical impression but all objective content is broken into geometric forms. A distinction is made between "Analytical Cubism" (up to ca. 1911) and "Synthetic Cubism" (1912 to mid-1920s).

Cubo-Futurism Early 20th-century style in Russia in which Cubist and Futurist influences are mixed.

De Stijl Dutch artists' group founded in 1917 by Piet Mondrian and Theo van Doesburg, whose abstract pictures constructed in pure colors of geometrical surface forms reflect a strand of Constructivism.

Fauvism [Fr.'wild animals'] A loose association of French artists that formed around Henri Matisse in 1905 and countered Impressionist color dissection with pure, unbroken color, which they used to construct their pictures, disregarding precision of representation.

Futurism Italian style set in train by the writer T. Marinetti and formalized in 1909 with the *Futurist Manifesto*. The attitude of the group was anti-academic, and its art was swayed by modern technology and the euphoria of speed.

Geometric abstraction Reduction of pictorial composition to clear geometric forms. Development of rhythmic surfaces by means of color. Rooted in Constructivism. Peaked in 1950s and 1960s.

GINKhUK State Institute for Artistic Culture, Leningrad 1924–1926.

gouache Painting technique with water-based colors that, unlike water colors, dry opaque rather than transparent. By mixing binders and opaque white, a pastel color effect is obtained, with a rough surface.

icon Originally a panel painting of the Greek Orthodox Church, which for centuries characterized a type of painting defined by firm traditions and strict patterns.

Impressionism Style developed in France around 1870 that captures the object in its momentary dependence on the light. Characterized by broken-up painting technique, bright coloration, and pictorial sections that often seem accidental; preferred subjects were landscapes and scenes from urban life.

landscape painting Representation of pure landscapes. Although initially landscape was an accessory for filling in background, by the end of the 16th century it had developed into an independent genre. The 17th century created the 'ideal' landscape (for example Claude Lorrain's transfigured landscapes) and 'heroic' landscape (for example Poussin). Landscape painting reached its apogee in the Dutch baroque. It was revolutionized in 19th century by the emergence of open-air (*plein air*) painting.

Leningrad See St. Petersburg.

MKhK Museum for Artistic Culture.

monochrome Monochrome pictures painted with a single color (or shades of that color). Originally called grisaille, it includes works by Malevich and Y. Klein.

Nabis [Hebrew: *nabi*, 'prophet'] French group of artists of late 1890s inspired by Paul Gauguin, which

adopted Symbolist pictorial subject matter and decorative forms of design.

Non-objective painting A 20th-century style in painting and sculpture, founded by Malevich around 1915 with his pure, uncluttered color surfaces. This developed into a non-objective representation that no longer focused on content but on color and form. Constructivism, Bauhaus, and De Stijl were early artist groups.

Op Art Style that flourished in the 1960s, exploring dynamic color and movement effects. It makes use of the eye's inertia, so that multi-colored structures are perceived as sculptural, mobile elements.

perspective [Lat. *perspicere*, penetrate by looking] Representation of objects, people, and spaces on a pictorial surface, as a result of which an impression of spatial depth is created by graphic and painterly means. Perspective was discovered scientifically in the Renaissance period and applied to painting. In central perspective, the parallel lines running into the depth of the picture meet at the vanishing point (linear perspective or vanishing-point perspective). Objects and people become smaller proportionally to distance, in accordance with the grid that is produced by the perspective lines. A further way of producing depth in a picture is color or aerial perspective, under which the things represented lose color intensity as the distance increases, and the color changes into bluish tones.

Petrograd See St. Petersburg.

portrait Representation of a person. Distinctions are made between self-portraits, single portraits, double portraits, and group portraits.

primary color The basic colors – red, yellow, blue – in painting. All other colors are achieved by a mixture of these. They themselves cannot be generated by mixing other colors.

St. Petersburg Second city of Russia: formerly known as Leningrad (1924–1990) and Petrograd (1914–24).

Socialist Realism Official style from 1932 in the Soviet Union, later also in its satellite states (especially the German Democratic Republic), that was aimed at the masses and was based on realism. Preferred subject matter for Socialist Realism and its often monumental paintings, was the world of the workers, showing scenes from the happy life lived under Socialism.

square This was the basic form of Suprematist art, which is contrasted with representational art. The first element of non-objective art.

Suprematism Style developed by Malevich from 1915 based on the primacy of the square. The new symbol communicated feelings directly. Feelings are evoked solely from the effect of pure geometric (hence also abstract) forms. The Suprematist "feels" art, he does not observe.

SWOMAS Free art studios, renamed VKhUTEMAS (Higher State Studios for Art and Technology) in 1920 and VKhUTEIN (Higher State Institutes for Art and Technology) in 1926. 1921–1926 in Moscow, 1921–1922 in Petrograd.

Symbolism Artistic movement of the second half of the 19th century, whose concern – in contrast with Realistic thinking – and subject matter was not visible in reality but the world of the mind, imagination, vision, and dreams.

UNOVIS Upholders of the New Art. A group founded in Vitebsk by Malevich in 1919.

VKhUTEMAS See SWOMAS.

weightless art Development of non-objective art that overcomes gravity and apparently defies the imperatives of weight.

Index

Acknowledgments

The publishers would like to thank all the museums, photolibraries, and photographers for allowing reproduction and their kind assistance in the publication of this book.

[t = top, b = bottom, r = right, l = left, c= center]

© Archiv f¸r Kunst und Geschichte, Berlin: cover, 4 br, 7 tl/b, 13 tl, 23 tl, 31 tl, 43 tl, 48 (photo: Erich Lessing), 53, 60, 61 tl, 71 b, 72 t/b, 75 tl, 83

© Arthothek, Peissenberg: 27, 52, 84 (photo: Blauel/Gnamm)

© Bridgeman Art Library, London: 24 t, 37, 45 b, 88 t/b

© Edimedia/Guillemot, Paris: 41 r

© courtesy Galerie Konrad Fischer, Düsseldorf: 89

© Galerie Gmurzynska, Cologne: 13 tr, 34 t, 43 tr, 79, 80

© courtesy Alma Law, Los Angeles: 35 b

With kind permission of Gebr. Mann Verlag, Berlin: 67

© courtesy Matthew Marks Gallery, New York: 91

© 1999 Museum of Modern Art, New York: 38, 63

© Collections Musée nationale d'art moderne/Cci/Centre Georges Pompidou, Paris: 68t

© Philadelphia Museum of Art, Louise and Walter Arensberg Collection: 40

© Rheinisches Bildarchiv, Cologne: 18, 23 b, 43 b, 58 b, 59 t, 75 b

© Scala, Florence: 73 b

© Jeannot Simmen, Berlin: 25, 81 tr/cr, 90 t/b

© State Museum of Music and Theater, St Petersburg: 31 b, 32, 33 b, 34 b, 35 t

© State Russian Museum, St Petersburg: 2, 4 tl/tr, 5 tl/tr/b, 6, 9, 10, 11 t/b, 12, 14, 16, 17, 19, 22, 23 tr, 24 b, 30, 31 tr, 33 t, 36 t/b, 41 l, 44, 45 t, 46, 50, 51 t/b, 56, 57 b, 61 tr, 64, 65

t/b, 66 t/b, 67 b, 69 t/b, 73 t, 74, 75 tr, 76, 77, 78 b, 81 l, 82 t/b, 85, 86 t/br/bl, 87 t/br/bl, back cover

© State Tretyakov Gallery, Moscow: 47

© Stedelijk Museum collection, Amsterdam: 4 bl, 13 b (Foundation Cultural Center Khardzhiev Charga), 15, 26, 28, 39, 42, 49, 57 b, 62

With the kind permission of Verlag der Kunst, Dresden: 54, 55 t/c/b.

© Yale University Art Gallery, New Haven; gift of Collection Société Anonyme: 29

All other illustrative material derives from the institutions named in the captions or the publishers library. The publisher has made every effort to obtain and compensate copyright permission for all the works shown in the illustrations. Should any other legitimate claims subsist, the persons concerned are asked to contact the publisher.

Selected Bibliography

Kasimir Malevich, *Essays on Art 1915–1928,* Vol. I-IV, ed. Troels Andersen, Copenhagen 1968–1978.

Kasimir Malevich, *Suprematism. 34 Drawings and Patricia Railing, On Suprematism. 34 Drawings – a Little Handbook of Suprematism,* 2 vols., Artists Bookworks 1990

Charlotte Douglas, *Malevich,* Thames and Hudson, 1994

Barbican Exhibition Catalog, *The Malevich Collection,* Booth-Clibborn Editions, 1999

Evelyn Weiss (ed.), *Kasimir Malewitsch. Werk und Wirkung,* Museum Ludwig Exhibition Catalog, Cologne 1995

Key

r = right l = left
t = top b = bottom
c = center

Cover:
Red House, 1932
Oil on canvas
63 x 55 cm
St Petersburg, State Russian
Museum

Illustration, p. 2:
Malevich, photo, 1925

Back cover:
Malevich in front of his
works, Leningrad, photo,
1924

© 1999 Könemann Verlagsgesellschaft mbH
Bonner Strasse 126, D-50968 Cologne
Editor: Peter Delius
Concept: Ludwig Könemann
Art Director: Peter Feierabend
Cover design: Claudio Martinez
Concept, editing of the original edition and layout: Alexandra Schaffer
Picture research: Jens Tewes
Production: Mark Voges
Lithography: Digiprint GmbH, Erfurt
Original title: Kasimir Malewitsch

© 1999 Könemann Verlagsgesellschaft mbH
Bonner Strasse 126, D-50968 Cologne

Translation from German: Paul Aston in association with Goodfellow
& Egan
Editing: Susan James in associaton with Goodfellow & Egan
Typesetting: Goodfellow & Egan
Project management: Jackie Dobbyne for Goodfellow & Egan
Publishing Management, Cambridge, UK
Project coordination: Nadja Bremse
Production: Ursula Schümer
Printing and binding: Sing Cheong Printing Co., Ltd., Hong Kong
Printed in Hong Kong, China
ISBN 3-8290-2935-7

10 9 8 7 6 5 4 3 2 1